How to Pass

HIGHER

Art & Design

Elaine Boylan and Stephanie Lightbown

HODDER GIBSON
AN HACHETTE UK COMPANY

The Publishers would like to thank the following for permission to reproduce copyright material:

Photo credits: **p.1** © kolaybirsey – Thinkstock/Getty Images; **p.34** top left, Claude Monet, *Rouen Cathedral, The Portal at Midday* – public domain; top right, Claude Monet, *Rouen Cathedral Façade* – public domain; bottom left, *22. St Matthias, Stoke Newington, London by William Butterfield*, 1964 by John Piper (Tate); bottom right, *South Lopham*, 1976 by John Piper (Tate); **p.42** mid-left, centre, Claude Monet, *Rouen Cathedral Façade* – public domain; mid-left, *22. St Matthias, Stoke Newington, London by William Butterfield*, 1964 by John Piper (Tate); **p.67** middle-top, © BUKAJLO FREDERIC/SIPA/REX Shutterstock; middle-centre, © BSIP SA/Alamy Stock Photo; **p.68** top right, Jabot Pin (1920) by Georges Fouquet; centre-right, Bracelet (1925) by Georges Fouquet; top and bottom left, © Dorothy Hogg, Photographs by John K. McGregor; **p.76** top left, © Dorothy Hogg, Photographs by John K. McGregor; top centre, Jabot Pin (1920) by Georges Fouquet; **p.79** and **p.85** © Blue Dancers, c.1899 (pastel), Degas, Edgar (1834–1917)/Pushkin Museum, Moscow, Russia/Bridgeman Images; **p.89** *Devil's Head* (2007), pre-burning photograph (left) © David Mach (photography by Richard Riddick at The DPC Studios, London); remaining images © David Mach (photography by Alan Laughlin, Edinburgh); **p.92** The J. Paul Getty Museum © Estate of André Kertész; **p.94** *Personal Values* by René Magritte (1952)/Artepics/Alamy Stock Photo; **p.100** *Guernica* by Pablo Picasso © The Print Collector/Alamy Stock Photo; **p.108** Just Add Water poster by Shepard Fairey, produced for the Drop In The Bucket benefit concert; **p.111** top left, courtesy of Muhammad Mahdi Karim via Wikipedia Commons; top right, © mazzzur – Thinkstock/Getty Images; bottom, © Martinan – Thinkstock/Getty Images; **p.113** © Victorinox, www.victorinox.com/uk/en/; **p.115** Purse by unknown designer [1660-1680] © Victoria and Albert Museum; **p.121** The Red House by Philip Webb and William Morris, courtesy of Ethan Doyle White via Wikipedia Commons; **p.133** © Imagestate Media (John Foxx)/Painted Backgrounds BS22; **p.143** © Imagestate Media (John Foxx)/Conceptual Backgrounds BS17

Acknowledgements: Thanks to the students and staff of the Art & Design departments at James Hamilton Academy and Mearns Castle High School.

Students working at various levels contributed artwork to illustrate the Expressive Art approaches, Case Studies and Portfolio Gallery sections. Particular thanks to Marcie George, Daniel Cohen, Rachel Masterton, Wezi Ngwira, Caera Walton, Eilidh Priest, Ryan Inglis, Adam Reid, Jacob Scoular and Emma McCallum.

Although every effort has been made to ensure that website addresses are correct at time of going to press, Hodder Gibson cannot be held responsible for the content of any website mentioned in this book. It is sometimes possible to find a relocated web page by typing in the address of the home page for a website in the URL window of your browser.

Orders: please contact Bookpoint Ltd, 130 Park Drive, Milton Park, Abingdon, Oxon OX14 4SE. Telephone: (44) 01235 827720. Fax: (44) 01235 400454. Lines are open 9.00–5.00, Monday to Saturday, with a 24-hour message answering service. Visit our website at www.hoddereducation.co.uk. Hodder Gibson can be contacted direct on: Tel: 0141 848 1609; Fax: 0141 889 6315; email: hoddergibson@hodder.co.uk

© Elaine Boylan, Stephanie Lightbown 2016

First published in 2016 by

Hodder Gibson, an imprint of Hodder Education,

An Hachette UK Company,

2a Christie Street

Paisley PA1 1NB

Impression number 5 4 3 2 1

Year 2020 2019 2018 2017 2016

Cover photo © vetre–Fotolia
Illustrations by Aptara, Inc.
Typeset in LegacySansITC-Book, 11/13 pts, by Aptara Inc.
Printed in Spain

A catalogue record for this title is available from the British Library
ISBN: 978 1 4718 6245 8

Contents

Introduction

This book is designed to help you to complete your Art & Design coursework successfully and to help you prepare for the Question Paper examination. It should help you to understand the course structure and how marks are allocated. A unique aspect of this book is the guidance which is included on the practical aspects of the course, which account for approximately 63 per cent of the marks.

Advice to users

The book contains overviews of the key aspects of the Higher Art & Design course:

Expressive Activity

Design Activity

Question Paper

These sections will outline the process you should follow in order to fulfil the assessment standards and will explain how the marking criteria are applied.

Case studies

Case studies are shown to give you further insights into the course and to give ideas of different approaches. These have been developed from real students' work. You should also know that, as it is a creative subject, there are no right or wrong approaches in Art & Design. However, the case studies should help you to understand the creative processes that you are required to demonstrate. It is important that you understand that there are many different ways of achieving the Assessment Standards and meeting the marking criteria. The case studies should help you to develop your own individual way of doing this.

Although it is impossible to cover every type of Portfolio within the scope of this book, whichever area you are working in, you will be able to gain inspiration and ideas which you can apply to your own work.

External assessment: the Portfolio gallery

A unique feature of this book is that it contains a visual representation of what Portfolios look like when they are hung up for external marking. This should let you see how different formats work and how important it is that your own Portfolio has visual impact and coherence.

Feature boxes

HINTS & TIPS

Examiner's tips are included throughout the book. This advice should help you to maximise your **marks**.

COMMON MISTAKES

Throughout the book, alerts will be given on **problems** which cause candidates to lose marks.

Teacher's feedback

Throughout the case studies, there are teacher's notes to let you see the feedback given at various stages. This should help you to understand the process followed by the student.

Evidence Required

Information is given on minimum evidence requirements for different stages of the Units and Portfolio.

National 5

Many of you will have achieved National 5 Art & Design before proceeding to Higher. There are similarities and differences between the two levels.

Similarities	Differences
• The course structure is very similar. • The amount of work required is similar. • There is an Expressive Art Unit and Portfolio. • There is a Design Unit and Portfolio. • The study of artists and designers is integrated with your practical units.	• The critical studies element is much more demanding. • The Question Paper is a greater proportion of the overall marks. • Practical work for the Unit and the Portfolio needs to be of a higher quality to pass.

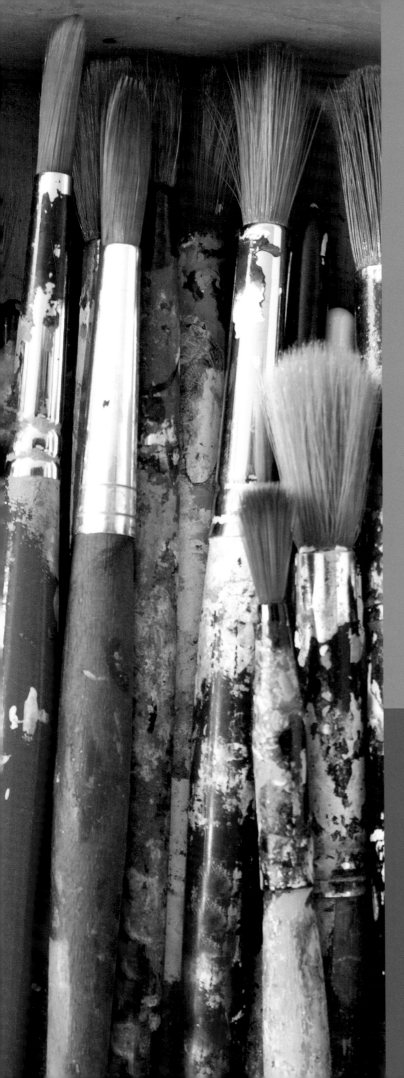

Chapter 1
Course Structure

- Component marks percentages
- Skills and knowledge
- Time management
- Homework
- Key deadlines

Course Structure

COMPONENT	ASSESSMENT ARRANGEMENTS		MARKS AVAILABLE
Expressive Activity	Unit	Internal assessment	Pass/fail
	Portfolio	External assessment	80
Design Activity	Unit	Internal assessment	Pass/fail
	Portfolio	External assessment	80
Question Paper	Examination	External assessment	60
		TOTAL	220

Component marks percentages

*Percentages have been rounded up/down to whole numbers.

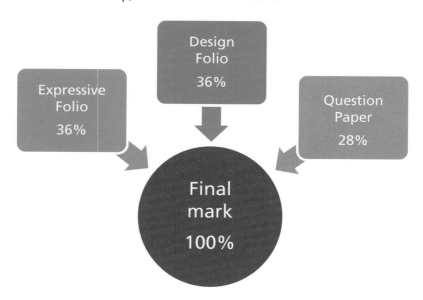

Skills and knowledge

In this course, you are being assessed on your ability to:

respond to an Expressive theme and Design brief in an effective and imaginative way

communicate personal thoughts, feelings and ideas effectively and skilfully in Expressive and Design activities

demonstrate problem-solving, critical thinking and decision-making skills in Expressive and Design activities

understand how artists and designers use materials and techniques for creative and visual effect

understand and analyse the impact of artists' and designers' creative choices in Expressive Art and Design works

plan, develop, produce and present creative Expressive Art and Design work

use Expressive Art and Design materials, techniques and technology in a creative and skilful way

reflect on and evaluate your own Art and Design work

understand and analyse the influence of social and cultural factors on Expressive Art and Design practice

Time management

Good time management is important to achieving success in the course. If you don't get the work done in time, your grade will be affected and you are unlikely to fulfil your potential. Your teacher has to submit your work to SQA for assessment. You will be expected to have your work completed well ahead of the SQA deadline. This is to allow your work to be checked and labelled. There are also important departmental quality assurance and administration procedures to be carried out which are very time-consuming for your teacher. This means that you cannot hand your work in at the last minute!

> ## HINTS & TIPS
> If you realise you are falling behind, don't ignore the situation. Speak to your teacher and ask about strategies which may help you to catch up.

Schools deliver the course in different ways, but your school will probably use one of the following three models:

Your school may cover the Design Activity first followed by the Expressive Activity:

Design Activity	Expressive Activity	Course Assessment: Portfolio submission

You might do the Expressive Activity followed by the Design Activity:

Expressive Activity	Design Activity	Course Assessment: Portfolio submission

Some schools do both activities concurrently. This means that you will complete your Expressive and Design Activities at the same time, dividing your lessons each week between both:

Expressive Activity	Course Assessment: Portfolio submission
Design Activity	

It doesn't matter which way your school delivers the course, but you should ensure that you are aware of key deadlines. Use the table on page 6 to record your main deadlines. If you have not been given this information, ask your teacher.

You should also find that the Expressive Activity and Design Activity checklists in this book will help you to keep track of your progress and make sure you have completed all of the tasks required for your Units and Portfolios.

Homework

You are unlikely to achieve your best grade without doing some extra work and practice at home. Your teacher may give you specific homework tasks which will help you work towards completing your Units and Portfolios on time.

At Higher level, you should be working fairly independently, using your initiative and planning what you could do at home to help you to make good progress. Ask your teacher what you are allowed to take home to complete if you are unsure.

If you are not given specific homework, there are many tasks which you can do at home which will save you time in class and which should help you to produce a Unit and Portfolios of good quality.

HINTS & TIPS

There are many things you can get on with at home, even with a limited range of materials.

Consider doing line drawings or sketches for design ideas – you will only need a pencil and paper!

HINTS & TIPS

Getting through your initial Unit work and making quick progress with your Portfolio will enable you to spend the maximum amount of time on your final outcomes. These are worth 36 marks each, so it is well worth putting in the time.

Homework tasks for your Expressive Unit and Portfolio might include:

- investigation on the work of artists
- line drawings which can then be worked into in class
- observational/analytical drawings using different techniques
- development studies
- annotation and evaluation.

For your Design Unit and Portfolio, you could complete:

- investigation on the work of designers
- market research
- initial ideas
- developing design ideas
- refining design drawings
- annotation and evaluation.

Critical studies homework could include:

- research on artists and designers related to your practical work
- analysis of art and design works
- revision and exam practice.

Use your initiative! Refer to the case studies and advice in this book to develop your own work.

Key deadlines

KEY DEADLINES					
		TASK		DATE	✓
Expressive Activity					
Unit		Initial studies (minimum three in different media)			
		Developments completed (minimum two developed ideas)			
		Integrated critical studies completed			
		Annotation/Evaluation completed			
Portfolio		Unit idea selected for further development			
		Developments completed (one focused line of development only)			
		Evaluation of development process and decision on final piece			
		Final piece completed			
		Evaluation of final piece completed			
		Presentation of Expressive Portfolio completed			
Design Activity					
Unit		Design brief completed			
		Research (including market research) completed			
		Development of ideas completed (minimum two developed ideas)			
		Integrated critical studies completed			
		Annotation/Evaluation completed			
Portfolio		Idea from Unit selected for further development			
		Developments completed (one focused line of development only)			
		Evaluation of development process and decision on design solution			
		Design solution completed			
		Evaluation of Design solution completed			
		Presentation of Design Portfolio completed			
Question Paper					
Question Paper		Prelim exam			
		SQA exam			

HINTS & TIPS

It is common to underestimate the time required to complete tasks. You may find that you need twice as much time as you think!

Pay attention to the deadlines set by your teacher. If you work quickly and with good focus in class and set aside plenty of time for homework tasks, this should allow you to get to the end of the course and meet all deadlines.

COMMON MISTAKES

Creative people have a tendency to leave things until the last minute, causing themselves unnecessary stress.

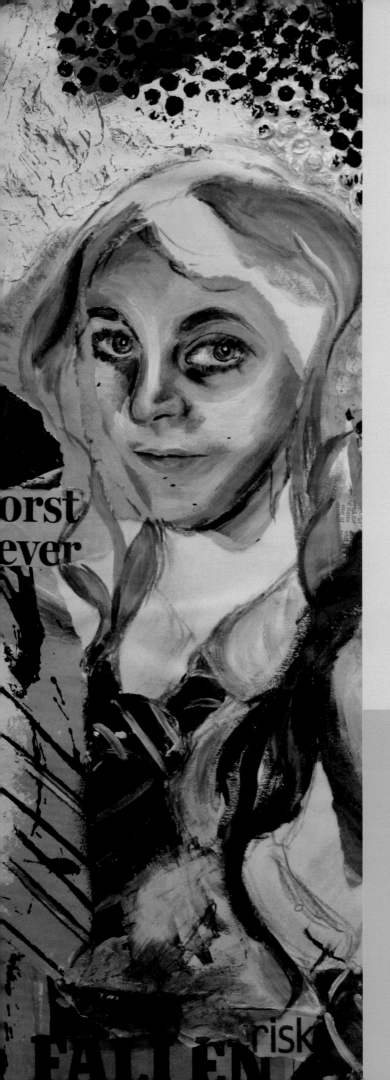

Chapter 2
Expressive Art Activity

2 Expressive Art Activity

Introduction and overview

What is Expressive Art?

Expressive Art is about responding to the world around you in a creative, visual way. Artists communicate their own personal ideas and develop their own styles by combining media and the visual elements in different ways. Expressive artists are not usually concerned with meeting the needs of a client – first and foremost, they are interested in expressing their own ideas. Expressive Art includes painting, print-making, photography, mixed media work, sculpture, installation and moving image work.

What will I be doing in this activity?

The creative process

In your Expressive Activity, you will be following a **creative process** to produce a Unit and Portfolio of work:

Title/Theme/Stimulus

Investigation and research

Development

Final outcome

Evaluation

How your Expressive Art Unit relates to your Portfolio

Select your theme/approach

Investigate inspirational artists' work – at least 2 works by each artist

Produce at least 3 investigation studies

Use at least 2 different media and techniques

Produce at least 2 developed ideas

Explore techniques and approaches

Evaluate and make decisions

UNIT

Marked internally on a pass or fail basis

Selection of ONE IDEA from the Unit to use as a starting point

FURTHER DEVELOPMENT and REFINEMENT of ONE IDEA

Compositions/Arrangements
Exploration of the visual elements, media and techniques

FINAL PIECE of EXPRESSIVE ART WORK

Effective realisation of a piece of Expressive Art work demonstrating visual continuity from and refinement of the original development work

EVALUATION

Analysis of the visual impact of your choice and use of materials, techniques and/or technology and the visual elements
Justified critical appraisal of the effectiveness of your Final Piece

PRESENTATION of the Portfolio for external assessment

PORTFOLIO
Marked externally by SQA

36 marks available

36 marks available

8 marks available

TOTAL 80 marks available

Expressive Art Unit

Your Unit is the starting point for your Expressive Activity, which will conclude later with your Portfolio which will be submitted to SQA for marking. Your Unit is an opportunity for you to develop your skills, and to experiment and try different ideas and techniques before you make decisions about the direction you would like to take with your Portfolio.

HINTS & TIPS

You must pass your Unit to complete the course, but it will not contribute to your overall grade. Although you must meet all of the Assessment Standards to pass, you should regard it as an opportunity to experiment and to make mistakes. Unit work does not have to be 'perfect'. Your teacher will be able to advise you when you have done enough to pass.

COMMON MISTAKES

A lot of students spend far too long on Unit work. If you do this, you may run out of time for your Portfolio. While it is important to develop your skills, it is not important to have highly finished Unit work which goes beyond the minimum requirements.

It is advisable move on to your Portfolio as soon as you are ready.

Expressive Art approaches

Another important aspect you will need to think about at the outset of your Unit concerns the Expressive approaches you will take. Your teacher will issue you with Unit task instructions and will advise you about what is realistic. You may want to think about (or ask your teacher):

- Will this project be about **2D** or **3D** work or a mixture of both?
- Which **media and techniques** will I be using? (e.g. painting, drawing, print-making, mixed media, sculpture, low relief).
- Do I need to provide the **subject matter** (e.g. objects, images, photographs), or will my teacher supply the resources?

Schools take a number of different approaches to the Expressive Activity. These include:

Single genre approach

You might be working in one particular **genre** (**category**). This is a popular approach, and may include:

PORTRAITURE

or

FIGURE COMPOSITION

or

STILL LIFE

or

THE NATURAL ENVIRONMENT

or

THE BUILT ENVIRONMENT

or

FANTASY AND IMAGINATION

HINTS & TIPS

If you take a single genre approach, you should still develop a title/theme for your work once your ideas and direction become clearer. This will help you to stay focused on a single line of development more effectively when you start your Portfolio.

Combined genres

You may also have the opportunity to work across genres, for example:

- a still life set on a windowsill with a natural environment or a built environment outside
- a portrait containing still life aspects (props used)
- a figure composition in a built environment
- a fantasy scene incorporating aspects of several genres.

Using a stimulus

A **stimulus** is something that gets you thinking and gives you ideas. Examples of stimuli used by artists include:

- **a symbolic object**
- **a special place**
- **a poem**
- **a song**
- **a story**
- **a photograph.**

Thematic approach

Themes allow you to make a **personal** response. The best themes suggest lots of visual ideas.

Genres themselves are not themes. For instance, **'Still Life'** or **'Landscape'** would not be suitable, as they are far too open-ended and don't suggest anything in particular.

You should choose a title, phrase or image, which suggests visual ideas. Examples might include:

- **A Few of my Favourite Things**
- **Sunlight and Shadow**
- **Making a Meal of It**
- **Dream Catcher**
- **A Different Point of View**
- **Misty Morning**
- **Woodland Walk**
- **Washed Up**
- **Abandoned**

The possibilities are endless!

Inspirational art approach

You will also complete critical studies work which will be related to your practical work. The critical studies tasks will help you to understand some key issues in Expressive Art and to develop your own approaches and techniques.

A productive approach for many students is to use the work of a particular artist or art movement as an influence in their own work. You may have been inspired by one of the artists you have studied in class, or you may have discovered the work of another artist as you have been investigating.

Your teacher will be able to advise whether your selected artist is a suitable and sensible choice for you to base your work on. Be prepared to keep persevering. In this approach, you should continue to research artists who reflect your own developing style as your work progresses. It is not unusual for a student's first choice of artist not to suit the way they actually like to work or the materials and processes available.

NOTE: Your teacher will probably offer you a limited choice. This is because departments often specialise in one or two areas which they have the expertise, equipment and resources to deliver. This should ensure that you get appropriate support and have the resources that you need to complete the project.

Your teacher also has to consider your level of skill and make sure that you don't attempt something that is beyond your ability and experience.

HINTS & TIPS

If your choice is limited by your teacher, this is not necessarily a bad thing.

Having restrictions can force you to be really creative.

Sometimes too many choices can make you indecisive and it can take you longer to get started.

Examples of student approaches

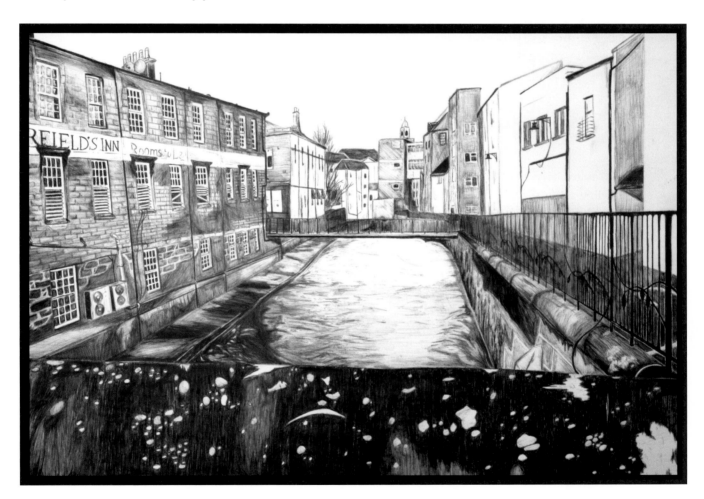

Adam worked in the genre of built environment on the theme 'My Town'.

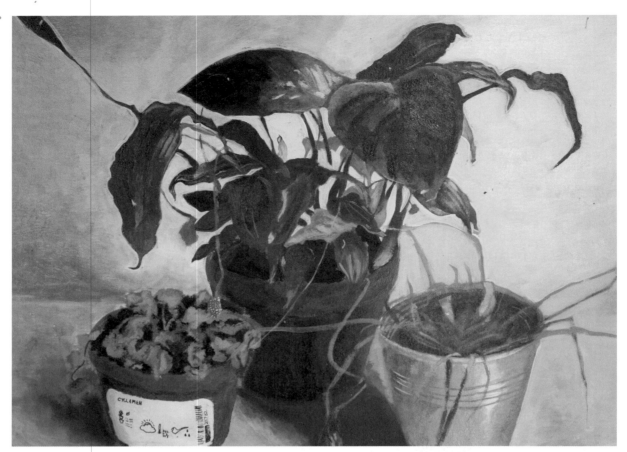

Eilidh was inspired by the work of Lucian Freud to produce a Unit and Portfolio on the theme entitled 'Neglected' using plants as her key subject matter. The artist's technique influenced her painterly approach.

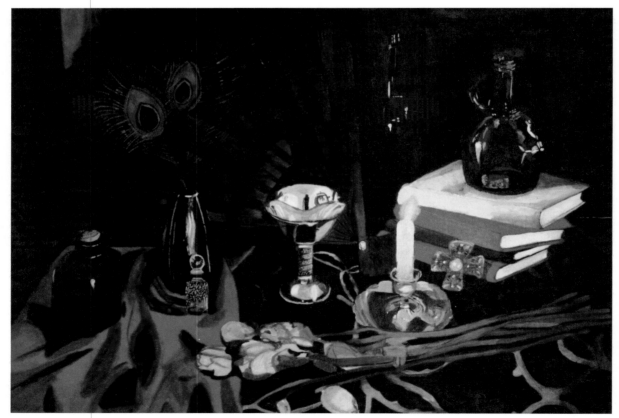

Rachel had studied the Vanitas painters and was inspired to include symbolic objects in her still life, which she entitled 'Memento Mori'.

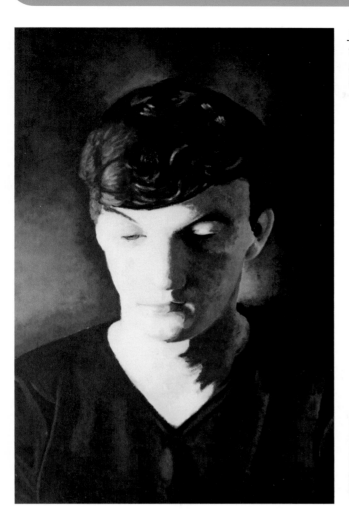

Jacob was working on a self-portraiture theme and was inspired by the work of the artist Ken Currie to create this dramatically lit composition.

HINTS & TIPS

It is important to note that, at the start of the course, none of these students knew exactly what their personal approach would be until they had worked through the Units and developed their own ideas and techniques.

Ryan had looked at the work of the Surrealists and incorporated some of their ideas about juxtaposing unusual subject matter.

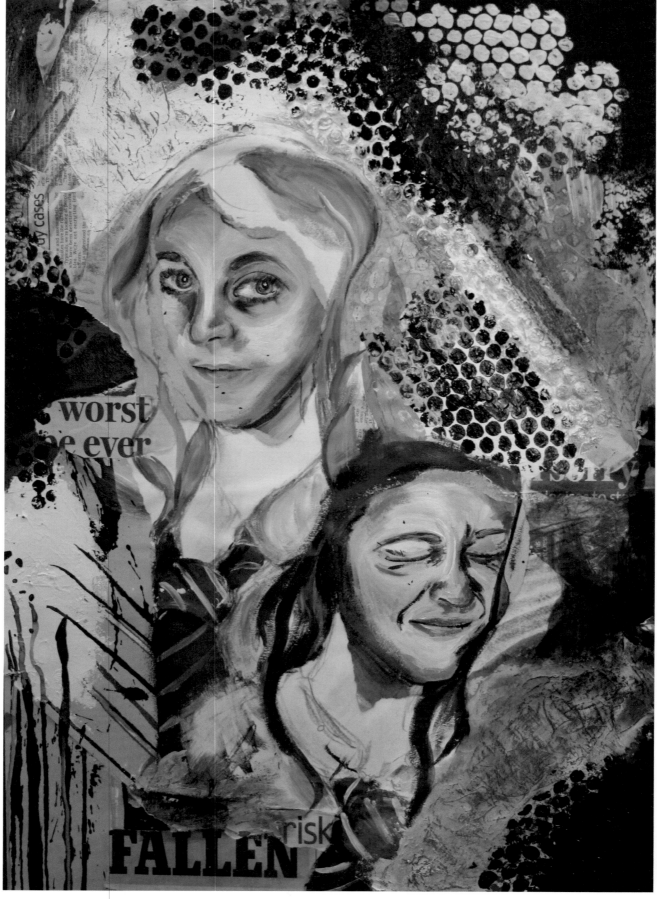

After studying Joan Eardley's portraits of children, Emma was inspired to create this energetic, mixed media piece entitled 'Sisters'.

The Expressive Art process

Expressive Art Unit: Investigation and research

This is the first stage of the process, and it is your opportunity to consider various possibilities. In your Unit, try to be open-minded about the direction you will take. Remember, this is a process of discovery and exploration. You will have to decide on one particular idea for your Portfolio, but in your Unit you can be more experimental.

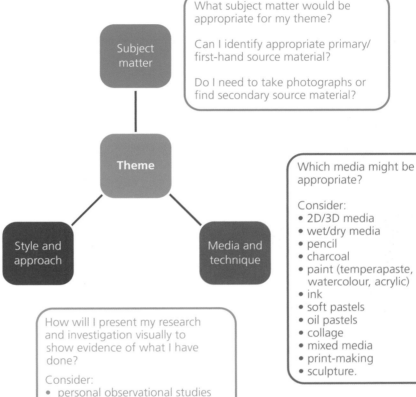

Subject matter

What subject matter would be appropriate for my theme?

Can I identify appropriate primary/first-hand source material?

Do I need to take photographs or find secondary source material?

Theme

Which artists will inspire and influence my work?

What style will it be?

Which key visual elements interest me the most?

Consider:
• colour
• line
• tone
• shape
• form
• pattern
• texture.

Will I work within one genre or work across genres?

What would be an appropriate scale for my work?

Style and approach

Media and technique

Which media might be appropriate?

Consider:
• 2D/3D media
• wet/dry media
• pencil
• charcoal
• paint (temperapaste, watercolour, acrylic)
• ink
• soft pastels
• oil pastels
• collage
• mixed media
• print-making
• sculpture.

How will I present my research and investigation visually to show evidence of what I have done?

Consider:
• personal observational studies
• cuttings/photographs
• experiments with media/techniques
• examples of artists' work
• annotation.

Where will I find what I need?

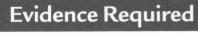

Evidence Required

Minimum of **three analytical studies** (2D or 3D as appropriate) demonstrating highly developed and proficient drawing skills and media handling techniques. These skills should include the ability to accurately depict form, detail and perspective, as appropriate.

Different media should be used and different qualities of the subject matter expressed.

Notes that you keep at this point will be useful for your Unit evaluation later.

Expressive Art Unit: Study of artists and artworks

In this aspect of the Unit, you will learn about the work of artists and analyse factors influencing Expressive Art practice.

Use of materials, techniques and/ or technology	• Describe and analyse how media, techniques and/or technology have been used • Demonstrate an understanding of appropriate art vocabulary

Impact of creative choices	• Analyse how the creative choices affect the visual impact of the work • Creative choices may include use of the visual elements, choice of style, choice of subject matter and compositional elements

Social and cultural influences on Expressive Art work	• Analyse the impact of significant social, cultural or other influences on the work • Make justified comments

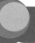

Evidence Required

Analysis of a minimum of **four Expressive Art works (two each by two different artists)**.

Evidence may be written, or recorded in another way. For example, it may be contained in a sketchbook, or notebook, or it may be a digital presentation.

COMMON MISTAKES

When investigating social and cultural factors, many students forget that they should be focusing on the impact of these factors on the Expressive Art work.

If you only write about the factors in general, this is not analysis. In order to pass this aspect of the Unit, you must demonstrate an understanding of how the factors have affected each art work.

For example, if you were investigating Picasso, you may write, *'Throughout his career, Picasso had many love affairs with different women.'* This is not an analytical comment. Instead you could have written, *'Each time Picasso had a new love affair, his style seemed to change, so different women influenced his work in different ways. This is clear in his Portrait of Dora Maar, which exhibits a more angular Cubist style with its jagged shapes and sharp edges.'* This comment is related to a particular Expressive Art work and is much more appropriate.

The diagram on the following page may give you a useful format for analysing Expressive Art works. You can customise this format in your sketchbook or jotter or on a digital presentation.

To help you analyse Expressive Art works

Imagery/Subject matter/ Sources of inspiration/Symbolism

Consider:
- the artist's choice of subject matter and/or theme and their reasons for this choice
- personal response to the subject
- style of the imagery
- what the symbolism means.

What inspired them to create this work?

Media handling/Technique

Consider:
- the choice of media
- how it has been applied.

What is the effect on the style of the work?

Key visual elements

Consider:
- line
- tone
- colour
- shape
- form
- pattern
- texture.

How are these combined and what is the effect on the work?

Scale

Consider:
- is it large or small scale?
- the effect on the detail or realism achieved
- the effect on visual impact.

Composition/ Arrangement

Consider:
- setting
- viewpoint
- perspective
- focal point
- proportion
- use of space.

What effect does it have on the work?

Add an image of the art work

- Find a good quality image.
- If it is 3D, try to find different viewpoints.

Mood/ Atmosphere

Consider:
- the mood and atmosphere communicated and how this has been achieved
- what the work says to you.

Title of work, name of artist, dates, media, dimensions

Social, cultural and other influences

Consider:
- cultural factors – whether the work is part of a specific movement in art – if so, what were the aims of that movement and what influenced the artist?
- What are the artist's 'trademarks' which can be seen in the work and what influenced this?
- historical factors – what was happening in the world at the time the work was created and how did this influence the work?
- social factors – how did changes in society or the expectations of society affect the work?
- scientific and technological innovations
- any other factors which influenced the work.

Visual impact/Success/ Effectiveness

Consider:
- what contributes to the visual impact of the work
- what makes the work successful/effective.

Ideas to influence my own work

Consider:
- what you have learned about the artist's technique/approach/style that you could try in your own work.

Expressive Art Unit: Development

Initial developed ideas

- Consider different possibilities in response to your genre/theme/title/stimulus
- Using your subject matter from the investigation studies, generate compositional ideas – try different arrangements of your subject matter
- Experiment with media and techniques

Selection of one idea for your Portfolio

- Review work done so far to see which idea has the most potential
- Select the most suitable idea for further development

Evidence Required

Minimum of **two developed ideas** (2D or 3D as appropriate) demonstrating the imaginative exploration, development and purposeful refinement of your expressive theme/stimuli, developed from your earlier drawings and studies.

There is no requirement for your work to be any particular size, so you should work in a scale with which you are comfortable and which is appropriate to the media and techniques used.

Notes that you keep at this point will be useful for your Unit evaluation later.

Expressive Art Unit: Evaluation

Problem-solving skills

- Plan next steps
- Identify issues/problems
- Consider suitable materials/techniques

Evaluation skills

- Review previous work
- Make realistic judgements and give reasons

Evidence Required

Produce an evaluation of your work, identifying strengths, weaknesses and opportunities for further development.

Your teacher may use the SQA Unit evaluation template from the Unit Assessment Support Pack, or a department template may be used.

Alternatively, you may be asked to annotate your work, and perhaps also to complete a separate evaluation.

It does not matter which format is used as long as the Assessment Standards are met.

To help you with your Expressive Art Unit evaluation

Your evaluation need not be lengthy; it is much better if it is concise and to the point, rather than rambling and unfocused. You are expected to identify and comment on the most important aspects of your Unit development process and to explain your creative decisions and next steps.

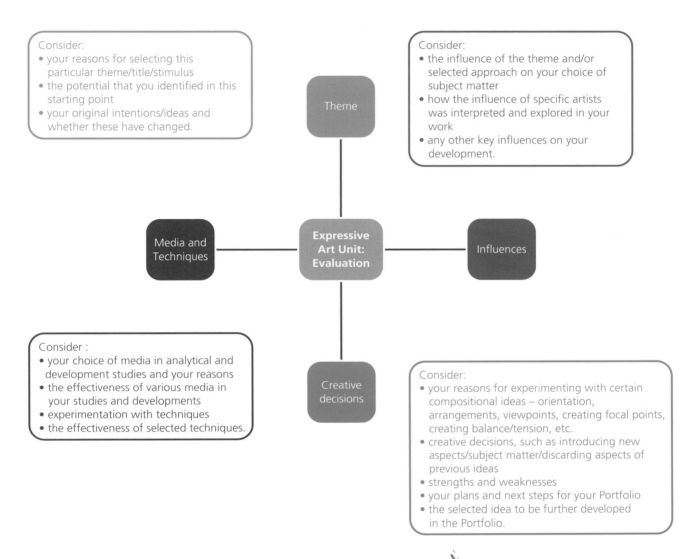

Consider:
- your reasons for selecting this particular theme/title/stimulus
- the potential that you identified in this starting point
- your original intentions/ideas and whether these have changed.

Theme

Consider:
- the influence of the theme and/or selected approach on your choice of subject matter
- how the influence of specific artists was interpreted and explored in your work
- any other key influences on your development.

Media and Techniques

Expressive Art Unit: Evaluation

Influences

Consider :
- your choice of media in analytical and development studies and your reasons
- the effectiveness of various media in your studies and developments
- experimentation with techniques
- the effectiveness of selected techniques.

Creative decisions

Consider:
- your reasons for experimenting with certain compositional ideas – orientation, arrangements, viewpoints, creating focal points, creating balance/tension, etc.
- creative decisions, such as introducing new aspects/subject matter/discarding aspects of previous ideas
- strengths and weaknesses
- your plans and next steps for your Portfolio
- the selected idea to be further developed in the Portfolio.

COMMON MISTAKES

Instead of evaluating, students often write a commentary of what they did. This is **not** evaluation. Evaluation involves making judgements about your own work and giving reasons for your opinions.

Remember to refer directly to particular examples of your work rather than making general statements.

Expressive Art Unit: Presentation

⬤ Evidence Required

You should have all of your Unit work available for assessment:

- **at least three analytical studies**
- **at least two developed compositional ideas**
- **critical analysis of the work of two artists – at least two Expressive Art works by each.**

Practical work should demonstrate visual continuity.

There is no requirement to mount Unit work, although your teacher may ask you to organise it for assessment, which may involve mounting it up on sheets. Many students complete their Unit work in a sketchbook, which keeps everything together.

It is YOUR responsibility to look after your work. If you lose it, you will have to replace it as the physical evidence must be available for assessment. If your school is selected by SQA for verification, your work needs to be available for viewing.

HINTS & TIPS

If you are using a sketchbook, do not be too 'precious' about it.

It is a visual record of your progress and may contain attempts that haven't worked as well as your more successful studies.

If your sketchbook is 'perfect' then you are probably not pushing yourself out of your comfort zone and experimenting enough!

Expressive Art Portfolio

Expressive Art Portfolio: Development

Development and refinement of the selected Unit idea	• Identify a starting point from Unit work • Produce **one line of further development** in response to the theme/title • Experiment with composition – consider viewpoint and arrangement • Explore media and techniques • Combine the visual elements to develop the intended style

COMMON MISTAKES

Sometimes students include more than one line of development in their Portfolio. If you do this, only the development work directly relating to your final piece can be awarded marks.

You should ensure that all work completed for development shows good continuity from the starting point to the final piece. Do not include anything which looks 'random' and out of place.

⬤ Evidence Required

There is no minimum or maximum number of studies, but you should try to produce **several** developments.

Quality is more important than quantity, but your work should effectively demonstrate the PROCESS you went through to develop your original idea towards your final piece.

Expressive Art Portfolio: Final piece

Scale and composition	• Decide on the best scale and format for the final piece • Select the most effective composition/arrangement

Media/technique	• Consider the intended style • Select the materials, including paper or most appropriate surface, if working in 2D • Consider the most suitable technique(s)

Further refinement	• Consider how the arrangement/composition will be refined, while still maintaining visual continuity with your development • Consider how media handling and use of the visual elements can be further refined/improved

Evidence Required

You should produce a final piece of creative Expressive Art work in an appropriate size. Work submitted can be up to A1 size, but it can also be much smaller (there is no minimum size). If you are working in 3D, your piece can be submitted or photographs sent instead (this is sometimes more practical, especially if the piece is large scale and/or fragile).

The final piece must show a strong visual link with previous work.

HINTS & TIPS

While you should be working independently and making your own decisions, it is a good idea to ask for advice on which media would suit your final piece best. Examiners often see outcomes where students have not selected the media which would have given them the most successful results and highest level of visual impact.

Your teacher can often see potential that you cannot!

COMMON MISTAKES

While large pieces of work can have good visual impact and suit the style of certain students, not everyone handles large scale work well. At times, students attempt to work on a scale which does not suit them and find that their work loses quality.

Some students are able to achieve a higher level of finish on a smaller scale while others, with a very expressive style, can find this restricting.

The key is to work on a scale which suits your own chosen style and technique.

Expressive Art Portfolio: Evaluation

Evaluation is an important aspect of your work. Many students find it difficult to evaluate their own Expressive Art work.

Analysing the visual impact of the Portfolio	• Choice and use of materials • Use of techniques and/or technology • Use of the visual elements

Critical appraisal of the effectiveness of the final piece	• Review against original intentions and ideas • Communication of the theme/title and how effectively this is achieved • Strengths and areas for improvement • Justification of opinions

COMMON MISTAKES

Many students write far too much for their evaluations. Some produce pages and pages of waffle which gains very few marks.

A lot of students tell the story of their work – this is not evaluation and cannot be awarded marks.

You should consider that there are only 8 marks available (4 marks each for the two areas outlined above). These marks are not difficult to achieve if your evaluation is focused, realistic and well justified.

Annotations throughout the development process are useful in that they can help examiners to understand your thought process, but this is **commentary**.

We recommend that you write around ten well-focused and well-justified evaluative comments. Approximately five comments should relate to the creative process followed in your Portfolio. The remaining comments should relate directly to the effectiveness of your final piece. Refer to the next section, as well as the case study, for advice on how you can do this.

Evidence Required

The evaluation should demonstrate that you can critically reflect on and evaluate the visual qualities of your Portfolio and your final piece of Expressive Art work using appropriate terminology.

Some schools use a template, while others ask students to annotate their work. Some schools use a mix of annotation and extended writing.

There is no minimum word count, but you must address all of the assessment criteria.

Marks are awarded for well-justified evaluated comments.

To help you with your Expressive Art Portfolio evaluation

Your Portfolio evaluation need not be lengthy; it is much better if it is concise and focused. You are expected to demonstrate that you can identify and comment on the most important aspects of your development and final piece of Expressive Art work. You should try to make realistic judgements.

Consider:
- the effectiveness of your use of composition – choice of format, arrangement, viewpoint, the focal point, whether you have created balance or tension, etc.
- any changes/improvements you could make to the composition of the final piece
- your original intentions – the selected theme and/or approach.

Consider:
- the most important visual elements in the work (line, tone, colour, texture, shape, form and pattern)
- what they contribute to the effectiveness of your development and the piece
- how they affect the style and visual impact of the work
- any improvements you could make in your use of the visual elements.

Composition

Media and techniques

Expressive Art Portfolio: Evaluation of your final piece

Key visual elements

Reflecting the theme

Consider :
- your choice of media and your reasons for this choice
- the effectiveness of your media handling in achieving the desired effect
- whether you could improve any aspects of your use of media and technique
- whether you might have selected a different medium or technique.

Consider:
- how well your final piece fulfils your original intentions
- if it reflects the mood and/or atmosphere intended
- if it communicates the theme effectively
- if there is anything you could change to ensure that your theme was reflected more effectively.

HINTS & TIPS

As well as discussing strengths of your development process and final piece, you should always identify some areas for improvement. You are expected to be self-critical. Even the greatest artists are rarely satisfied with their own work. Nothing is prefect! ☺

How to develop descriptive comments into evaluative comments

HINTS & TIPS

When evaluating, the following formula may help you:

Identify the issue

- make a statement or give an opinion.

Explain/Conclude

- give further detail
- justify the point
- give reasons
- make judgements
- discuss the resulting effects or decisions.

BASIC COMMENTARY	EFFECTIVE EVALUATIVE COMMENT
I chose the theme 'Woodland Walk' for my Portfolio.	The theme 'Woodland Walk' appealed to me as I enjoy landscape and had become interested in the woodland studies of Gustav Klimt during my critical studies work. You can see the influence of this artist in my woodland subject matter. He also influenced my technique as pattern is a key element in creating visual impact in my final piece. This can be seen in the repetition of the tree trunks. The influence can also be seen in the use of colour, which is applied in a stylised way, emphasising the pattern of the fallen leaves.
My final piece was completed using oil pastel.	I made the decision to use oil pastel in my final piece. This helped me to complete the work quite quickly and to incorporate a lot of expressive mark-making, reminiscent of the style of Van Gogh, which was my original intention. The media gave me bold vibrant colour and a directional linear 'brush stroke' effect, which contributed successfully to the visual impact.
I decided to include a piece of ribbon in the composition.	I included a piece of ribbon in the foreground of the composition. This is because I discovered that many still life artists include objects which create diagonal leading lines. This device helps to lead the viewer's eye into the painting. I thought that a ribbon would be a good addition as it fitted well with my 'Sewing Basket' theme.

BASIC COMMENTARY	EFFECTIVE EVALUATIVE COMMENT
I used air-drying clay to create my sculpture.	Air-drying clay was used. This allowed me to achieve the rounded forms inspired by Henry Moore in my final sculpture. However, it was not the easiest material to handle as it dried very quickly and was sticky, which I found frustrating. I had to work hard to get the smooth effect I intended. I had previously worked with this material on a smaller scale with no problems, and I chose it because it would not need to be fired. I feel I could have improved the finish of the piece by using ordinary clay instead.
I am very pleased with my final painting.	I am pleased with my final painting which is effective in communicating my theme of 'Dream Catcher'. I combined a selection of different elements: objects which would not normally be placed together, along with a dreamcatcher in the background, juxtaposed with a fantasy landscape. This helps create a surrealistic, dream-like effect which I feel is an imaginative response to the title of the work.
I created a gloomy mood in my mixed media piece, entitled, 'Abandoned'.	I created a gloomy mood in my mixed media piece, entitled 'Abandoned'. The subject matter of the abandoned building and its treatment helps add to the desolate mood. The neutral colour palette emphasises the melancholy atmosphere. The mixed media technique was very effective in building up layers of texture and in portraying the building in the run down condition which I intended. If I was going to change anything, I would add more negative space in the background – more sky and landscape around the building to add to the 'abandoned' effect.
I achieved a Cubist style in my 3D head sculpture.	I achieved a Cubist style in my 3D head sculpture. The clay head has fragmented planes, sharp geometric angles and is very stylised. My final outcome effectively reflects the style of Brancusi and Picasso, who were major influences on my work. The influence of Brancusi is particularly strong as I applied a metallic finish to the sculpture to make it look as if it was made of bronze. I am particularly pleased with this effect, although I could have taken a bit more care with the finish, as some of the tool marks are still visible here and there in the clay.

COMMON MISTAKES

Many students overcomplicate their evaluations and try to pack too much into each statement. If you do this, it can be very confusing for the reader. Keep your sentences short and try to deal with one point at a time.

Expressive Art Portfolio: Presentation

Do

- consider your Portfolio format and how it will communicate your creative process most effectively.

- think about using a vertical format, which tends to hang better. Horizontal formats can sometimes fold in on themselves.

- add your theme or title on the first sheet. This can help the examiner to understand your work better.

- include the starting point from your Unit. This can be the actual study or a photograph or photocopy.

- label your starting point clearly.

- include an example of inspirational art work if your Portfolio has been influenced by the work of a particular artist.

Don't

- overlap important work or create fold-out sections – the examiner may not see this work.

- feel as if you have to fill the maximum 3 × A2 sheet allocation. Quality is more important than quantity.

- include investigation studies. These may be impressive, but the examiner cannot award them any marks.

- include more than one line of development. There should be nothing which looks unrelated to the starting point or final piece.

- print or write your evaluation double-sided. The examiner may not see the second page.

- exceed the maximum space allocation of 3 × A2 sheets (or equivalent).

COMMON MISTAKES

At times, students do not include the selected idea from their Unit, which was the starting point for their Portfolio. It is very important for the examiner to see this idea as they have to allocate marks for how well this idea has been developed and refined.

Some students include the idea, but do not label it, so the examiner cannot tell which development is the starting point. This makes it very difficult for the examiner to make judgements.

Use the checklist on this page to help you keep track of your Expressive Activity and ensure that you fulfil the assessment criteria.

		Task	Success criteria	✓
EXPRESSIVE ACTIVITY CHECKLIST				
Unit	1	Starting point	I have selected a theme/title/stimulus.	
	2	Investigation and research including critical studies	I have completed at least **three** analytical studies of subject matter related to my theme/title/stimulus of the appropriate quality.	
			I have completed critical studies research showing that I have learned about a range of artists.	
			From my critical studies, I have selected at least **two** different artists and analysed at least **two works** by each.	
			I have included annotations to explain my thoughts and decisions.	
	3	Unit Development	I have completed **at least two** compositional developments which explore my theme/title/stimulus and are of an appropriate quality.	
			I have explored a variety of relevant materials and/or techniques.	
			I have selected the most successful idea for further development.	
	4	Evaluation	I have evaluated my Unit work and planned my next steps.	
Portfolio	5	Portfolio Development	I have produced a range of further developments based on my selected idea, exploring it through adapting and refining the composition, media and technique.	
			I have added annotations to explain my thoughts and decisions.	
	6	Final Piece	I have planned my final piece, taking account of the time, resources, materials and skills required.	
			I have produced my final piece to the best standard I am capable of.	
			If appropriate (for 3D work) I have photographed my final piece, or arranged for it to be photographed.	
	7	Evaluation	I have evaluated the effectiveness of my Portfolio and final piece with reference to the realisation of my ideas.	
	8	Portfolio Presentation	I have discussed the most suitable presentation format with my teacher, considering shape and size of card/paper.	
			I have included the selected development idea from my Expressive Unit as a starting point, along with a relevant example of an artist's work (if appropriate).	
			I have arranged my work into a suitable layout, so that the creative process is clear, and checked this with my teacher before proceeding.	
			I have carefully and neatly stuck down my work, including my final piece (and/or included photographs of my final piece, if 3D).	
			I have included the evaluation of my Portfolio and final piece in an appropriate format.	
			The separate sheets of my Portfolio have been securely taped together on the back.	
			The labels supplied by SQA have been stuck onto the back of my Portfolio.	
Well done – you've made it!				

Gothic Architecture

Expressive Art Case Study

2

EXPRESSIVE
UNIT AND
PORTFOLIO

Marcie's assessment task instructions

Marcie's teacher adapted the SQA Unit Assessment task instructions to suit the approach her class would be taking.

The Built Environment

You will produce creative development ideas for the production of a 2D Expressive Art outcome based on a selected aspect of the built environment.

You may consider one of the following themes:

- Urban Decay
- Gothic Architecture
- The Scheme
- Victorian Heritage
- Main Street
- My Town
- Industrial Landscape
- Architectural Detail
- Modern Abstraction

As part of your research and investigation, you will:

- Select a minimum of **two artists** who have produced work in this genre and then select a minimum of **two examples** of each artist's work – this should relate to your own intended approach.
- Describe how your chosen artists used art materials, tools, equipment/technology and techniques in their work.
- Analyse the effect of the artists' creative decisions in the examples of their work.
- Analyse the factors which influenced the artists and their work.

Many artists have produced work in this genre including Arthur Grimshaw, Claude Monet, Edward Hopper, John Piper and George Shaw to name but a few.

You will produce this artist research as a PowerPoint presentation.

In your sketchbook, you will:

- Produce a minimum of **three** detailed drawings and/or studies based on your selected theme.
- Develop and refine a minimum of **two** compositional ideas for the 2D outcome.
- Use a minimum of at least **two** different art materials and **two** different techniques and approaches for expressive effect.
- Reflect on your expressive development ideas as you work through the process by annotating your work.

Complete the evaluation worksheets to record your thoughts and decisions.

Expressive Art Unit: Investigation and research

Marcie chose the Gothic Architecture theme from the selection offered. She planned to get started by visiting Edinburgh and the surrounding area to look for inspiration, take photographs and make sketches. On her visit, she made quick observational drawings.

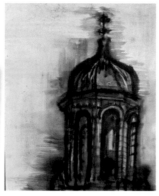

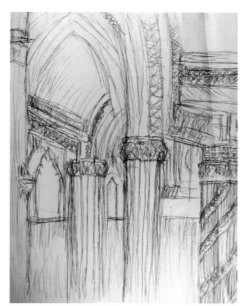

HINTS & TIPS

Good quality observational drawing is the key starting point for every Expressive Activity. At this stage, consider subject matter which would be appropriate to your chosen theme.

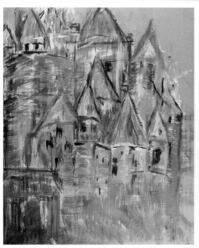

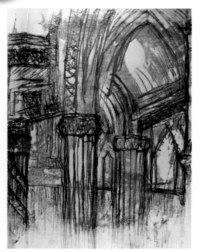

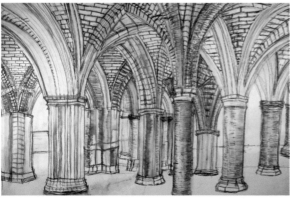

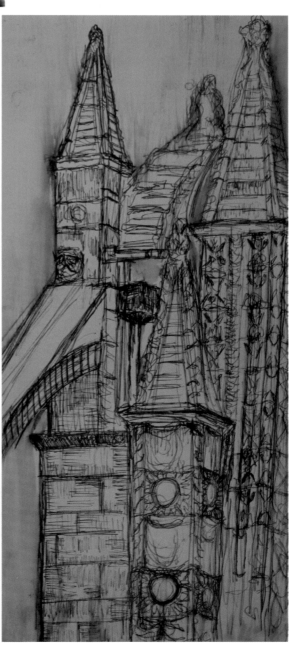

While on her visit, Marcie began exploring some of her preferred techniques, such as charcoal on a prepared ground, white chalk and ballpoint pen. She has a natural gestural, sketchy style and these materials allowed her to complete a number of quick studies on site. Marcie was required to produce at least three investigative drawings for her Unit. She found that she was able to produce more, including a monoprint, when she returned to school. This gave her more of a choice of imagery when it came to the development stage of the process.

Expressive Art Unit: Study of artists and artworks

Marcie chose to look at the work of two artists which she felt related well to her own subject matter. She selected two works by each artist which she wanted to investigate further. She felt this would help with her development. She looked at the Rouen Cathedral series by the Impressionist artist Claude Monet. Marcie was interested in the fact that the artist had painted the façade of the building at different times of the year and in different lighting conditions. This completely changed the colour palette of each work.

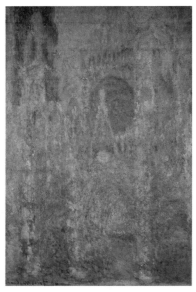

After researching Monet's approaches, she discovered that he was more interested in painting the light reflecting from the building rather than the structure. He applied dabs of thick paint to build up the effect of the changing light.

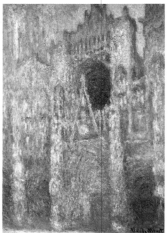

Rouen Cathedral, Portal at Midday (1894) by Claude Monet
materials: oil on canvas

Rouen Cathedral (1893–1894) by Claude Monet
materials: oil on canvas

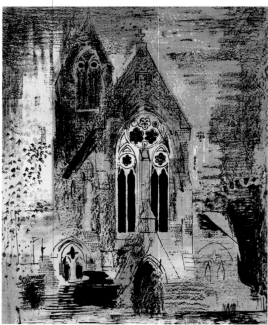

St Matthias, Stoke Newington, London (1964) by John Piper
materials: lithograph on paper

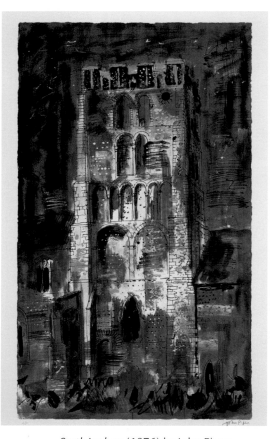

South Lopham (1976) by John Piper
materials: screen print on paper

John Piper was the second artist selected by Marcie. He also painted Gothic buildings, such as churches and cathedrals. He was influenced by his time as a war artist during the Second World War, which meant that he had to draw and paint very quickly. This impacted on his style and Marcie liked his use of mixed media and his expressive technique.

Expressive Art Unit: First line of development

When investigating her theme at first, Marcie looked at many different kinds of structures in the built environment which reflected the title 'Gothic Architecture'. As she began to create developments, she was influenced by the work of the artists she had researched in her critical studies. Back at school, working from her drawings and photographs, she was inspired by the work of Monet to try some experimental techniques with colour.

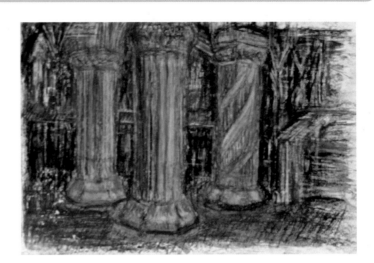

HINTS & TIPS

Like Marcie, you may find that it takes a while at this stage to discover techniques that are right for you. Don't expect everything to work first time. Students often find it difficult to break out of their comfort zone and try new methods. You may feel a bit 'lost' at this point and this is perfectly normal. Persevere and this feeling will pass.

Marcie explored collage, wax resist techniques and working with a palette knife. This loosened up her technique and made her more confident with gestural mark-making.

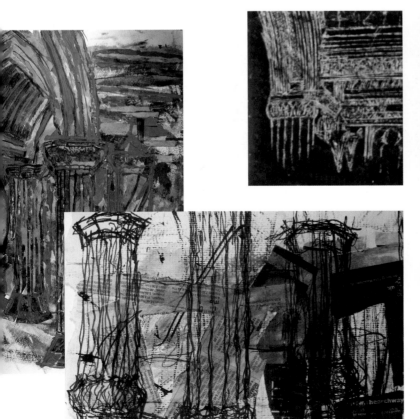

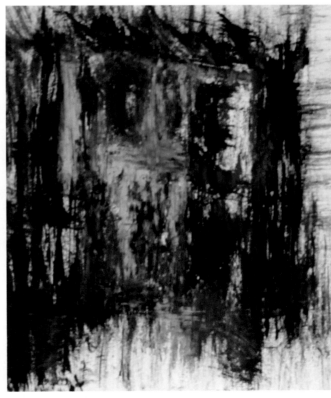

As Marcie began to find a direction with her work, she became interested in the details of the Gothic architecture and the repetition of the pillars.

Expressive Art Unit: Second line of development

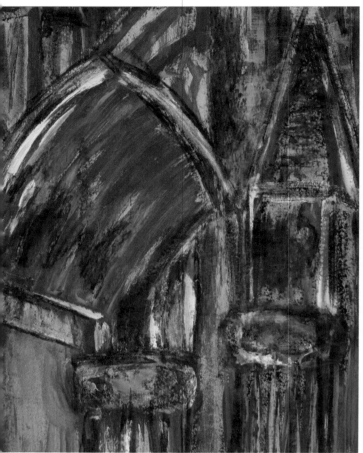

Marcie began another line of development. She had become more interested in one specific building, Rosslyn Chapel. At this point, she was influenced by John Piper's work and decided to explore a warmer colour palette as a contrast to the cooler palette of her first line of development.

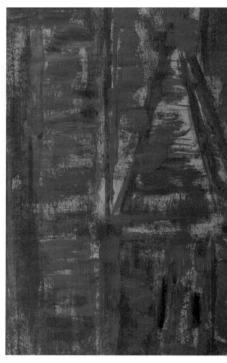

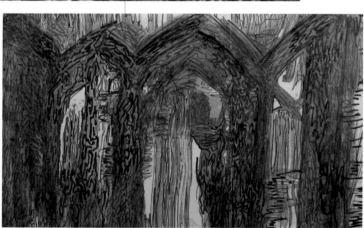

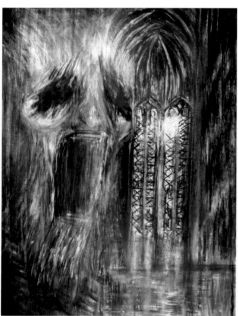

Teacher's feedback

Marcie, the cooler colours are starting to creep back into your colour palette. I thought that you intended to work in warm colours only in this line of development? Try to ensure that these developments have a unified style relating to Piper's work.

Teacher's feedback

Marcie, this image with the ghostly screaming face is out of context with the rest of your work. Consider whether you want to pursue this more surreal idea as you would need to produce further development work. My advice would be to stay focused on your original intentions.

Marcie's Unit evaluation

Marcie's teacher gave her a template adapted from the SQA Unit Assessment Support Pack to ensure that all the important points were covered.

Creative Process: My Comments On Artists and Their Work
Outcome 1: Assessment Standards 1.1, 1.2 and 1.3

My chosen art works

Rouen Cathedral (1893–1894) by **Claude Monet**, oil on canvas

Rouen Cathedral, Portal at Midday (1894) by **Claude Monet**, oil on canvas

St Matthias, Stoke Newington, London (1964) by **John Piper**, lithograph on paper

South Lopham (1976) by **John Piper**, screen print on paper

Opinions on the art works

Claude Monet is one of the famous painters of the twentieth century. He was a key member of the Impressionist art movement which focused on capturing light. He was interested in light and atmosphere and the effect of light on the surface of the building. He has succeeded in capturing the effect of light on the façade of the cathedral at different times and weather.

John Piper's works, in contrast, portray the grim toll of the war – bombed out scenes, with buildings partly destroyed. His work is dark and atmospheric through his use of colour, such as black and red in the South Lopham print and the monochromatic colour scheme in the St Matthias print.

What I learned about the use of materials and techniques to communicate their ideas

In the Rouen Cathedral paintings, Monet worked with an unconventional composition, focusing on only part of the building from an apartment he had rented directly opposite. He often painted straight from the tube and this gives the painting texture. He scumbled colours (using thin, broken layers of paint which allows the lower layers of colour to shine through.) Monet built up texture through his brushstrokes, which varied from thick to thin. He painted a number of canvases at the same time and swapped them around as the weather conditions changed so he could capture the light at the same time of day. Monet often created a series of paintings of the same subject.

John Piper completed many of his architectural studies through the technique of print-making. Piper used technical print-making processes such as lithograph and screen-printing. However, after closer inspection of the print border, I think he used a more painterly approach to print-making using large brushes onto the printing plate to create the dark backgrounds. His use of line is fluid and he captured the structure of the buildings quickly with strong decisive marks.

Significant social and cultural influences on the artists and their work/approach

In my study of Monet's paintings of Rouen Cathedral I discovered that the Impressionist art movement was an important turning point in the history of art and society. During the Industrial Revolution, the expanding railway network allowed for easy transport to different places. Monet travelled to different locations to paint. Portable easels and pre-mixed tubes of oil paints became available for the first time, allowing artists to paint outside the studio. New pigments became available, which created new vibrant colour palettes for the Impressionist artists.

The introduction of photography changed the way artists looked at the world and encouraged cropping, unusual perspectives and compositions which influenced Monet's composition. Monet focused on the Rouen Cathedral main entrance and cropped the main structure of the building.

Many factors influenced Piper's works, including those of churches, which I chose to study. One of the main influences was his time as a war artist (1940–42). War artists were commissioned to document the war through art. The government commissioned this art to create a record of the war. The Second World War lasted for five years and changed society as we know it. From this experience, Piper was used to working quickly to document the bombed out buildings. This way of working stayed with him even when there was no longer any urgency to finish his work. This influenced his style as Piper completed rapid sketches, full of movement. He used his sketchbook like a camera and there is a gestural mark-making energy from his drawing. These energetic marks were then carried on into his print-making.

How I could use aspects of this knowledge in my own work
Looking at Monet's and Piper's work has encouraged me to focus on Rosslyn Chapel as my subject. Monet's cropped compositions and multiple paintings of the same view have given me confidence to thoroughly explore one specific area. From John Piper, I am inspired to try print-making techniques, such as monoprinting, as well as mixed media, particularly collage. I love the freedom of John Piper's work and would like to have a more energetic linear quality to my own work. I would like to experiment with more expressive mark-making and resist techniques which would emphasise the linear structure and textures of the Gothic architecture.

My Expressive Ideas: My Chosen Subject Matter, Art Materials and Techniques

Outcome 2: Assessment Standards 2.1, 2.2, 2.3, 2.4 and 2.5

My creative choices and decisions – how I approached planning and developing my ideas for art work
By visiting Edinburgh and Rosslyn Chapel to complete drawings and take photographs, I was able to return to school and plan my next steps for composition and technique development. I decided to explore viewpoints and colour palettes which helped me with the development of my ideas. I had a lot of different images, but I could see how I could follow two separate lines of development reflecting my theme of Gothic architecture. One line of development involved the architecture I saw in the city centre and the other focused on Rosslyn Chapel.

Knowledge and skills I have gained or developed – creative challenges and opportunities and how I responded to them
Initially, I felt that my work was too sketchy and appeared unfinished. My teacher pointed out that this was an expressive style of work and she encouraged me to look at artists who also work in this way. After researching other artists, such as Giacometti, who worked in a linear and gestural mark-making manner, I discovered John Piper, whose subject matter was more like my own. This gave me the confidence to continue in this style and explore it further. I worked in techniques I have never tried before and have particularly enjoyed mixed media work.

How my choices and decisions affected the look of my Expressive Art work — strengths and areas for improvement in my approach
Studying the artist Monet was a turning point for me personally, as it gave me the idea of the exploration of a single building. My work progressed more after studying this work. I also decided to concentrate on the limited palettes for my further development. I like working really fast and have produced multiple experimental studies in a short period of time. To improve my work, I now need to concentrate on developing a range of tonal values, which will give the drawing more structure and depth.

Strategies for further improving and refining my work and ideas
I need to ensure that I keep the energy of my sketches when I start working at a larger scale. I would like to add texture to my work by adding repeated layers of paint, ink and charcoal. I will need to remember to stand back from my work on a regular basis to see the progress of the work as it evolves.

Expressive Art Portfolio: Development

Unit starting point

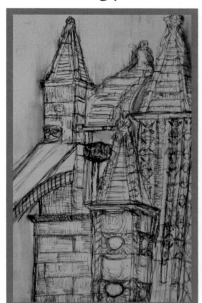 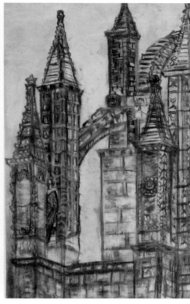 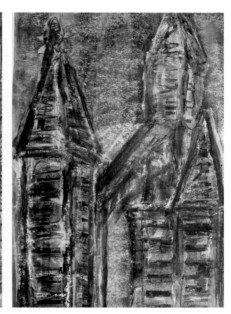

Marcie selected a drawing from her Unit which was to be the starting point for her Portfolio. She decided on a particular detail of Rosslyn Chapel. Her intention was to develop this idea using a limited neutral palette with warmer accents and to refine the expressive techniques developed during her Unit. Marcie's teacher advised her to mount this image to differentiate it from the rest of her Portfolio and to indicate her starting point to the examiner. Marcie chose to use red, since this was to be an important accent colour throughout her Portfolio.

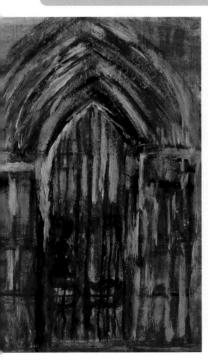

In her further development, Marcie was influenced by both of the artists she had studied. She was inspired by Piper's colour palette and mixed media approach. Monet's cropped compositions influenced her arrangements and his gestural brushwork encouraged her to be bold with her technique and to use lighter tones to emphasise the form and detail of the building.

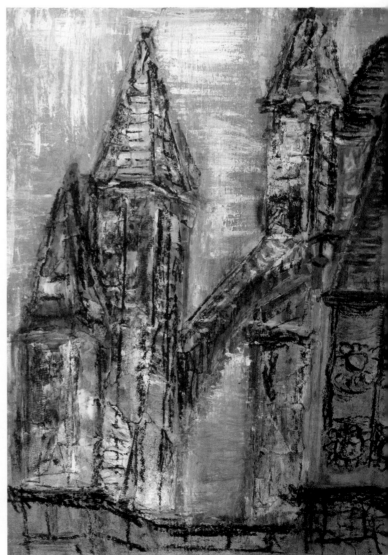

The archways and doors of Rosslyn Chapel provided Marcie with interesting subject matter to depict and scope to experiment further with her techniques.

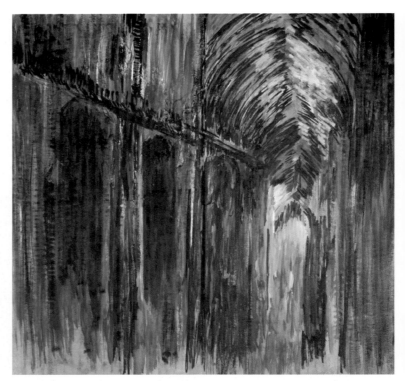

Marcie enjoyed experimenting with different media and she particularly liked the textural layers she could create with oil pastel and ink wash. She found that she could redraw areas that had lost definition. Expressive mark-making techniques and layers of brushwork added energy to her compositions. As she progressed her confidence increased and her style became more assured.

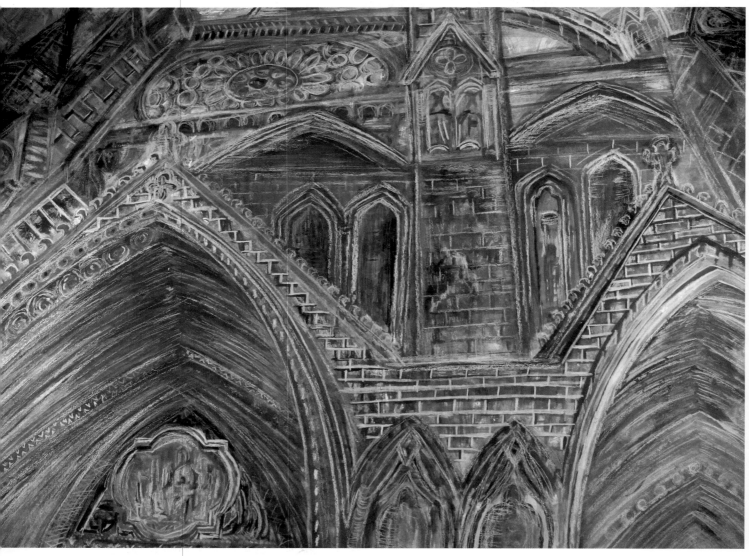

Expressive Art Portfolio: Final piece

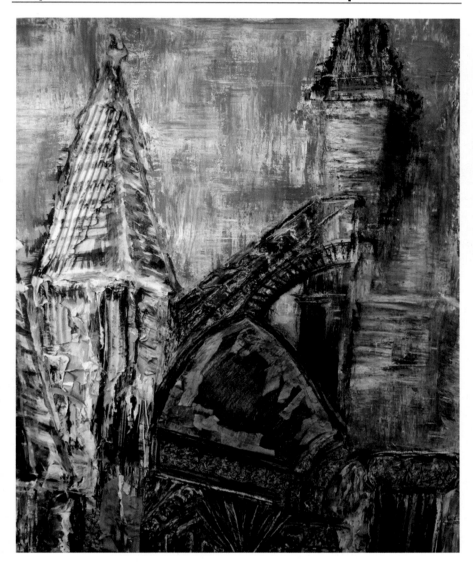

As her developments were completed on a small scale, Marcie had space left to produce a larger scale final piece. She chose to work on the maximum A1 size to make the most of her textural mixed media techniques and to create maximum visual impact.

HINTS & TIPS

Although Marcie chose to work on a large scale, not all students are comfortable working big. In fact, some students produce their best work on a small scale. You should not feel compelled to fill the space. When it comes to the final outcome, quality is more important than quantity.

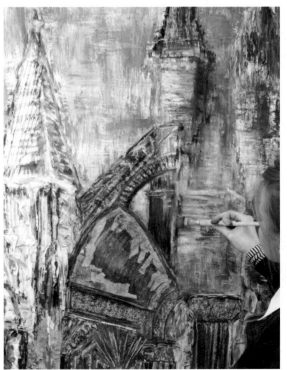

Finished Expressive Art Portfolio

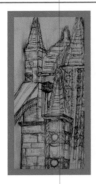

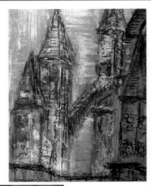

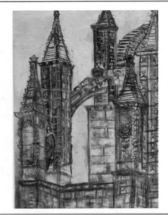

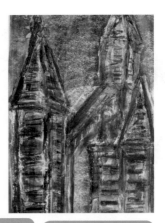

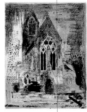

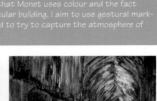

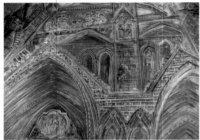

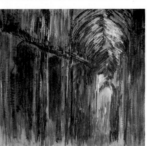

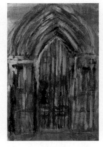

I was inspired by the artists, Claude Monet and John Piper, during my Unit and these artists will have a significant impact on the direction of my Portfolio. I like the way that Monet uses colour and the fact that he focused on one particular building. I aim to use gestural mark-making influenced by Piper and to try to capture the atmosphere of Rosslyn Chapel.

In my development, I enjoyed experimenting with a variety of media. As my work progressed, I found a mixed media approach suited my subject matter and helped me to achieve the expressive effect I was after. By combining media, I was able to build up layers and refine areas to add definition, which suited the way I like to work.

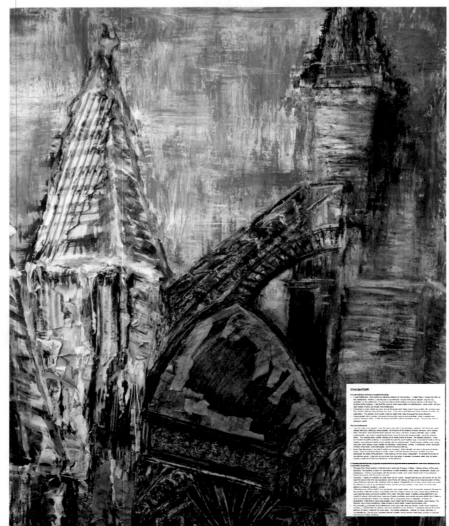

Marcie's Portfolio evaluation

As there are 8 marks available for evaluation, Marcie's teacher advised her to produce 8–10 bullet points of concise evaluative comment on her Portfolio and final piece. She was encouraged to focus closely on the assessment criteria by using sub-headings.

Analysing the visual impact of my choice and use of materials, techniques and/or technology and the visual elements on my Portfolio

Use of materials, techniques and/or technology

- I used photography when gathering reference material for my Portfolio. I visited Rosslyn Chapel and took my own photographs. However, I also felt that it was important to draw from life on location and not rely completely on the photographs. This drawing stage and the sketches I produced allowed me to explore the structure of the building. I feel that this gave the studies in my development a depth of understanding which would not have been possible if had I just worked from photographs.
- I developed a mixed media approach during the development stage which I later incorporated into my final piece. This involved applying layers of paper and card. I also used a resist technique which involved oil pastel and watercolour. This allowed me to create a textural effect which helps to suggest the rough stonework.
- I experimented with a number of unusual drawing tools such as card and sticks, which produced more angular, expressive marks. I liked the energy generated by these handmade brushes. This gave my work an expressive quality.

The visual elements

- Line was a key visual element. Using the more linear style I had developed, combined with the mixed media collage technique, effectively communicated the structure of the building through expressive mark-making in my studies.
- Other important visual elements that I explored were colour and tone. I used a restricted colour palette in my development, predominantly red, which I used to develop tonal values through the monochromatic use of this singular colour. This reduced colour palette allowed me to create a sense of drama. The detailed stonework, which surrounded this Gothic building, I represented through the use of multiple lines. I was able to build up strong shadows using different weights of line applied with ink and charcoal. I built up layers of tone using washes and more mark-making which created an interesting multi-layered surface. I introduced strong highlights through white pastel, which emphasised the form of the arch doorway, a technique I found particularly effective.
- Using these techniques, I was able to capture an impression of the intricate carvings on the spires of Rosslyn Chapel in my sketches and studies. These have a fluid organic quality, which I captured through overlaying multiple lines that emphasised the detail of the stonework while allowing for the viewer's imagination to recreate the drama of this soaring skyline. I feel that my use of line, tone and colour produced a dramatic mood and my media handling captured the ethereal atmosphere of the cathedral.

Critically appraising and justifying the effectiveness of my final piece of Expressive Art work with reference to the realisation of my ideas

- The scale of my final painting is the first area I would like to discuss. Initially I found working at this scale daunting. The painting is nearly A1 and scaling up after completing much smaller development studies was challenging. However, I am pleased with the expressive quality and visual impact which I have achieved through persevering with the larger scale work.
- Originally, I began my painting on white paper but very quickly realised that this was not working for me. The lack of a neutral mid-tone was distracting and it was proving too difficult to build up the range and depth of tonal values that were required. After a tutorial with my teacher, I decided to work on brown card, which was similar to a technique I used in my development studies and this gave my painting a base which was much more effective in creating the depth I wanted.
- At the beginning of the project I never considered using mixed media. When I originally conceived the idea for this painting I did not visualise using collage but when I began working on such a large scale I felt that by using textured papers such as corrugated brown paper with other media, it added surface effect that I was unable to achieve with paint alone. Layering of media eventually gave me the expressive effect which I liked in some of my development studies. I am pleased with my final piece; it was a realisation of months of development. I felt that my final piece created visual impact due to its scale and complex mark-making. The painting has a strong atmospheric effect through its warm colour palette and dramatic tone.
- The composition contributes to the effectiveness of the piece. After studying Claude Monet's Rouen Cathedral paintings, I concentrated on zooming into areas of interest on one building. I specifically focused on the arched doorway of Rosslyn Chapel for my final piece. This cropped composition, inspired by Monet's approach, is representational, but has some successful abstract qualities mainly because of the scale, zoomed in viewpoint and expressive media handling. However, on reflection, I feel that I may have cropped the composition too much and I could have refined certain areas more, to add more detail and a better sense of perspective.

HINTS & TIPS

Each section of the evaluation is worth 4 marks. You must write about both aspects to gain full marks.

Using sub-headings and bullet points is a good way to organise your writing and make your comments clear to the examiner.

COMMON MISTAKES

Instead of evaluating, a lot of students write a story about their work in general, detailing what they did.

In an evaluation, you must make judgements about whether what you did was effective, or not, and explain why.

Chapter 3
Design Activity

3 Design Activity

Introduction and overview

What is design?

Design is about coming up with ideas to solve a problem, or meet a need. Designers consider aesthetics (appearance and style), function, materials, production and construction methods. Designers also have to make their designs appealing to a target market or a particular client.

What will I be doing in this activity?

The design process

In your Design Activity, you will be responding to a **design brief** and working through a design process to produce a Unit and a Portfolio of work:

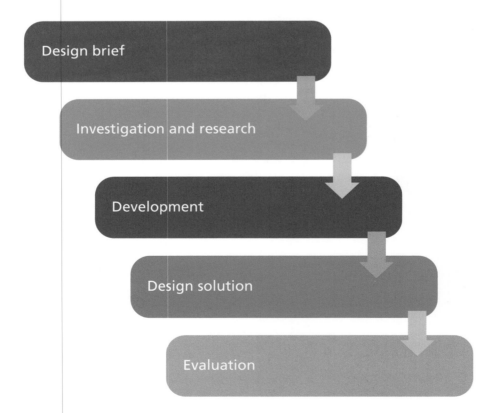

Design brief

Investigation and research

Development

Design solution

Evaluation

How your Design Unit relates to your Portfolio

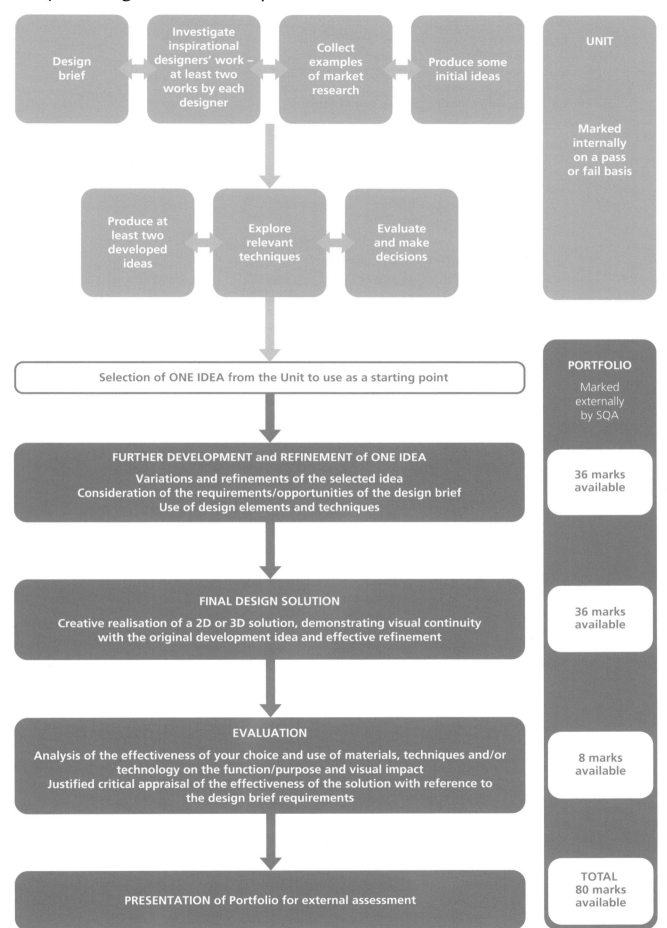

Design brief

Investigate inspirational designers' work – at least two works by each designer

Collect examples of market research

Produce some initial ideas

UNIT

Marked internally on a pass or fail basis

Produce at least two developed ideas

Explore relevant techniques

Evaluate and make decisions

Selection of ONE IDEA from the Unit to use as a starting point

PORTFOLIO

Marked externally by SQA

FURTHER DEVELOPMENT and REFINEMENT of ONE IDEA

Variations and refinements of the selected idea
Consideration of the requirements/opportunities of the design brief
Use of design elements and techniques

36 marks available

FINAL DESIGN SOLUTION

Creative realisation of a 2D or 3D solution, demonstrating visual continuity with the original development idea and effective refinement

36 marks available

EVALUATION

Analysis of the effectiveness of your choice and use of materials, techniques and/or technology on the function/purpose and visual impact
Justified critical appraisal of the effectiveness of the solution with reference to the design brief requirements

8 marks available

PRESENTATION of Portfolio for external assessment

TOTAL
80 marks available

Design Unit

Your Unit is the starting point for your Design Activity, which will conclude later with your Portfolio which will be submitted to SQA for marking. Your Unit is an opportunity for you to develop your skills, and to experiment and try different ideas and techniques before you make decisions about the direction you would like to take with your Portfolio.

Design areas

You will work within a particular design area:

GRAPHICS

or

PRODUCT DESIGN

or

ARCHITECTURAL/ENVIRONMENTAL/ INTERIOR DESIGN

or

JEWELLERY

or

FASHION/TEXTILES

NOTE: Your teacher may not offer you a choice of design area, or may offer you a limited choice. This is because departments often specialise in one or two areas which they have the expertise, equipment and resources to deliver. This ensures that you get the support and the resources that you need to complete the project.

Sometimes students get anxious about not being able to work within a specific Design area. For instance, a student may be interested in studying architecture at university, and might become concerned that this is not a discipline which their Art & Design department delivers. Meanwhile, in a neighbouring school, another student intends to study fashion at art school, but their class is doing an architecture project! Even if you plan to pursue a career in a particular area of Art & Design, colleges, universities and art schools will understand if you have not had the opportunity to study this particular discipline at school and will not expect it. They will usually be looking for evidence of creativity in general and that you are serious enough to do some work in your own time, for instance by keeping sketchbooks.

The Design process

Design Unit: Design brief

The design process is essentially a problem-solving activity, which you complete step by step. The first step is the **design brief** which gives you information on requirements and constraints (restrictions).

Evidence Required

A design brief which identifies the key design opportunities, issues and constraints.

Your brief should be specific enough to give you the information you need but open-ended enough to allow you to be creative. Your brief should contain information on functional issues, aesthetics and target market.

COMMON MISTAKES

Examiners often comment on students' design briefs which are too open-ended and unrealistic, or which are too restrictive and so limit creativity.

A good design brief will give you direction and encourage your creativity. You should also ensure that you have selected a brief which is within your capabilities.

Design Unit: Investigation and research

This is the part of the process where you should be thinking about what you need to find out in order to solve your design problem successfully. At this point, it is worth spending some time planning what you are going to do. The following diagram should give you some ideas:

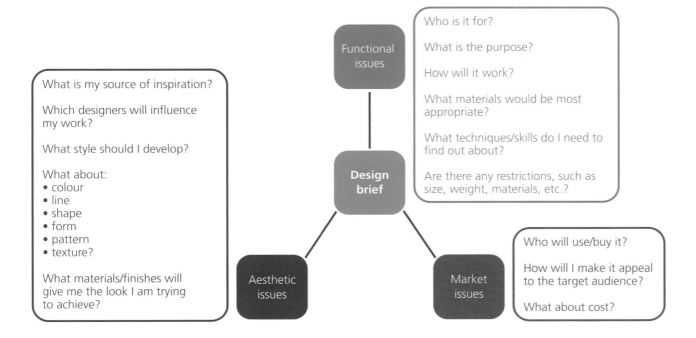

Evidence Required

- Design brief
- Sources of inspiration – for example, photos/cuttings/printouts/ personal drawing
- Market research/images of designers' work/information
- Annotation

Design Unit: Study of designers and design works

In this aspect of the Unit, you will learn about the work of designers and analyse factors influencing Design practice.

Use of materials, techniques and/ or technology	• Describe and analyse how media, techniques and/or technology have been used for specific effect • Demonstrate an understanding of appropriate Design vocabulary

Impact of creative choices	• Analyse how the creative choices affect the function, visual impact and aesthetic appeal of the work • Creative choices may include use of the visual and design elements, choice of style

Social and cultural influences on Design work	• Analyse the impact of significant social, cultural or other influences on the work • Make justified comments

Evidence Required

Analysis of **a minimum of four Design works (two each by two different designers)**.

Evidence may be written, or recorded in another way. For example, it may be contained in a sketchbook, or notebook, or it may be a digital presentation.

The diagram on the next page should help you to analyse design works effectively. You can customise the format for use in your sketchbook or jotter or as part of a digital presentation.

HINTS & TIPS

Remember to comment on the Design works, rather than giving general information on the life and times of the designers. You must relate the social and cultural influences directly to their impact on each design.

You also need to do this in the Question Paper exam, so it is a good idea to get used to working this way.

To help you analyse Design works

Function

Consider:
- the functionality of the design
- its purpose – think about primary and secondary functions
- fitness for purpose
- wearability (fashion/jewellery)
- practicality
- ergonomics and anthropometrics
- health and safety issues
- durability.

Aesthetics/Style

Consider:
- key visual elements – such as line, tone, colour, texture, shape, form, pattern and how these are combined for visual effect
- sources of inspiration
- scale
- detail/decoration
- visual impact.

Materials/Techniques

Consider:
- choice of materials
- properties of the materials
- processes used; production/construction methods
- skills used
- use of technology (if appropriate)
- effect on function and appearance
- suitability
- effect on cost.

Add an image of the design work

- Find a good quality image.
- If it is 3D, try to find different viewpoints.

Target market/ Audience

Consider:
- what type of audience/ market the design is aimed at
- the typical consumer/ specific client
- age group
- gender group
- income bracket
- personality traits and preferences
- why the design appeals to a specific market …

Title of work, name of designer, date, materials, dimensions

Social, cultural and other influences

Consider:
- cultural factors – whether the work is part of a specific movement in design – if so, what were the aims of that movement and what influenced the designer?
- what are the designer's 'trademarks' which can be seen in the work and what influenced this?
- historical factors – what was happening in the world at the time the design was created and how did this influence the work?
- social factors – how did changes in society or the expectations of society affect the work?
- scientific and technological innovations
- any other factors which influenced the work.

Visual impact/Success/ Effectiveness

Consider:
- what contributes to the visual impact of the work
- what makes the work successful/effective.

Ideas to influence my own work

Consider:
- what you have learned about the designer's technique/approach/ style that you could try in your own work.

Design Unit: Development

COMMON MISTAKES

Development is more challenging than research and investigation. It is very common for students to spend far too long on research and investigation, particularly in Design work. It is very enjoyable and not particularly difficult!

However, you may later regret not moving on sooner. If you do not start your development work as soon as you can, you may run out of time and your work may be rushed at the end.

Initial developed ideas	• In your Unit, consider different possibilities in response to your design brief • Using your research and investigation work as a starting point, generate some ideas • Experiment with materials and techniques • Refine at least two of your ideas

Selection of one idea for your Portfolio	• Review work done so far to see which idea has the most potential and relates best to your design brief • Select the most suitable idea for further development

This stage of the process is where you create your own ideas in response to the brief.

Evidence Required

Minimum of **two separate developed ideas** (2D or 3D as appropriate) showing refinement and demonstrating:

- an individual and creative response to the design brief
- problem-solving skills
- purposeful experimentation with materials, techniques and technology, as appropriate.

Notes that you keep at this point will be useful for your Unit evaluation later.

HINTS & TIPS

Keep referring to your design brief, so that you do not lose direction.

Do not be too precious about your work at this stage – some of your ideas may not be successful.

COMMON MISTAKES

Some students become fixated on their first idea and are reluctant to develop it further. You are very unlikely to have come up with your best idea yet! Keep pushing yourself and you will probably surprise yourself. It is important to show creativity.

Students often find Design development challenging. Sometimes ideas are not developed enough and become repetitive, or they are developed too much and become different ideas entirely. You are only required to show **two lines of development in your Unit** and **one line of development in your Portfolio**, so it is better if your development is tightly focused on one line of development at a time; this means that you will get used to working in this way.

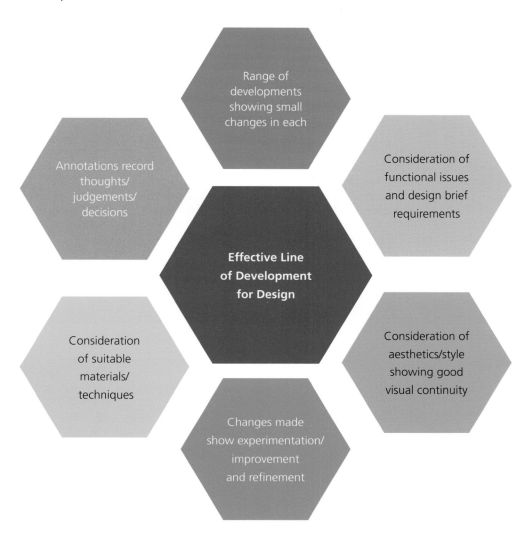

The following suggestions for ways to develop your work in specific Design areas may help you:

Graphic Design

- Stylise the imagery in different ways.
- Make changes to the layout and experiment with scale and proportion.
- Experiment with the typography.
- Experiment with visual elements – colour, line, shape, pattern, texture, form (in packaging).
- Consider repetition of imagery and motifs.
- Consider improvements to the visual impact.
- Make improvements to the function (clarity of communication).
- Make changes which may appeal to the target audience.

Product Design

- Create 2D sketches and 3D 'sketch models' (rough models using material such as card, corrugated card, recycled materials and masking tape, as appropriate).
- Photograph your 3D models, so that you can deconstruct or change elements.
- Change the form to reflect the intended style and to improve visual impact.
- Consider ergonomics and anthropometrics to make the product more user-friendly and have more appropriate dimensions for the target audience.
- Experiment with visual elements – colour, line, shape, pattern, texture, form.
- Create samples to experiment with construction, materials and finishes.
- Use ICT or traditional perspective drawing methods to show the product from different viewpoints.

Architecture/ Environmental Design

- Create 2D sketches and 3D 'sketch models' (rough models using material such as card, corrugated card and masking tape).
- Photograph your 3D models, so that you can continue to deconstruct or change elements.
- Consider construction methods and suitable materials.
- Change the form to reflect the intended style and to improve the visual impact.
- Consider how the building/structure will be used and how people will move through it.
- Consider windows (use of natural light) and door placement, and how the space will be divided up (if appropriate).
- Experiment with visual elements – colour, line, shape, pattern, texture, form.
- Use ICT or traditional perspective drawing methods to show the structure from different viewpoints. Create plan views, elevations and perspective drawings.

Interior Design

- Create 2D sketches and 3D 'sketch models' (rough models using material such as card, corrugated card and masking tape, as appropriate).
- Photograph your 3D models, so that you can continue to deconstruct or change elements.
- Consider how the space will be divided up (if appropriate) and how people will move through it.
- Consider style and placement of fixtures and fittings.
- Consider decoration and its appeal to the target audience.
- Experiment with visual elements – colour, line, shape, pattern, texture, form, as appropriate.
- Use ICT or traditional perspective drawing methods to show the interior from different viewpoints. Create plan views, elevations and perspective drawings.

Jewellery Design

- Develop 3D motif(s) or elements based on your source of inspiration.
- Consider ways of repeating motifs or further developing 3D elements and experiment with changing the scale.
- Create 2D sketches and 3D 'sketch models' (rough models using material such as card, corrugated card, recycled materials and masking tape, as appropriate) to experiment with how the jewellery will be worn on the body.
- Photograph your 3D models on a mannequin or on the body so that you can deconstruct or change elements easily.
- Consider fastenings and how the jewellery willl be constructed and secured.
- Experiment with visual elements – colour, line, shape, pattern, texture, form, as appropriate.
- Create samples to experiment with materials and finishes.

| Textile Design | • Develop motif(s) based on your source of inspiration.
• Experiment with ways of stylising and developing the motif(s) if working with repeat pattern(s).
• Use ICT or traditional methods to experiment with different ways of repeating the motif – stripes, mirror, rotation, half-drop, regular, irregular, etc.
• Try changing the scale of your motif(s) and mixing different scales.
• Experiment with design elements – colour, line, shape, pattern, texture, form, as appropriate.
• Create samples to experiment with materials, fibre, yarn and fabric manipulation techniques, embellishments and finishes. |

| Fashion Design | • Create 2D fashion drawings – consider the back and front of the garment.
• Make changes to the placement of decorative elements to improve the visual impact.
• Experiment with design elements – colour, line, shape, pattern, texture, form, as appropriate.
• Consider fitness for purpose and how the garment will be constructed – traditional or nontraditional methods.
• Consider practical issues and how the design will fit the body. Remember to consider fastenings, if appropriate.
• Make samples to experiment with materials and techniques to show how aspects of your garment might be constructed/embellished. |

Design Unit: Evaluation

| Problem-solving skills | • Plan next steps
• Identify issues/problems
• Consider suitable materials/techniques |

| Evaluation skills | • Review previous work
• Make realistic judgements and give reasons |

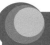

Evidence Required

Produce an evaluation of your work, identifying strengths, weaknesses and opportunities for further development.

As you progress through your Unit, you may be asked to produce mind-maps, or to annotate your Design work, and perhaps to complete a separate evaluation at the end. Your teacher may use the SQA Unit evaluation template from the Unit Assessment Support Pack, or a department template may be used.

It does not matter which format is used as long as you fulfil the Assessment Standards.

To help you with your Design Unit evaluation

Your evaluation need not be lengthy but should be focused and to the point. You are expected to demonstrate that you are able to identify and comment on the most important aspects of your Unit development process. You should also explain your creative decisions and next steps.

Consider:
- the requirements of your brief and how well you have addressed these
- function/fitness for purpose, style and target audience/market
- how well you dealt with any constraints.

Consider:
- the influence of your sources of inspiration
- how you took inspiration from your market research
- how the influence of specific designers was interpreted and explored in your work
- any other key influences on your development.

Brief

Materials, techniques and technology

Design Unit: Evaluation

Influences

Creative decisions

Consider:
- how you experimented with materials
- the effectiveness of various techniques in your developments
- how you made use of technology (if appropriate).

Consider:
- your reasons for experimenting with certain approaches
- reasons for particular changes to designs
- your use of the visual elements and the creative effect
- strengths and weaknesses
- your plans and next steps for your Portfolio
- the selected idea to be further developed in the Portfolio.

COMMON MISTAKE

Students are sometimes reluctant to point out weaknesses in their own work. Your teacher will already be well aware of what has been less successful and will be impressed that you are being objective and self-critical.

If you have difficulty deciding if an idea is successful, discussing it with your teacher or peers can be helpful.

Design Unit: Presentation

Evidence Required

You should have all of your Unit work available for assessment:

- **design brief**
- **market research**
- **any other relevant research and investigation, such as notes, images, drawings**
- **at least two developed ideas**
- **critical analysis** of the work of two designers – **at least two design works by each**.

Practical work should demonstrate visual continuity.

There is no requirement to mount Unit work, although your teacher may ask you to organise it for assessment, which may involve mounting it up on sheets. Many students complete their Unit work in a sketchbook.

Remember that it is YOUR responsibility to look after your work. If you take it home and lose it (or leave it on a bus!) you will have to replace it, as the physical evidence must be available for assessment. If your school is selected by SQA for verification, your work will need to be available for viewing.

Design Portfolio

Design Portfolio: Development

Development and refinement of the selected Unit idea	Identify a starting point from Unit workProduce **one line of further development** in response to the requirements and opportunities of the design briefMake further refinements and improvements to the original ideaExplore media, techniques and technologyApply the visual elements and design elements effectively to fulfil the design brief

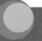

Evidence Required

There is no minimum or maximum number of developments, but you should be able to produce **several** developments showing various considerations and refinements.

Brief annotations are also helpful in explaining your thought process at this stage, which will be helpful to the examiner.

COMMON MISTAKES

In Design Portfolios, students sometimes produce a range of ideas which do not have a strong visual connection. This is not development. It is much easier to generate lots of new ideas than to develop and improve on an existing idea. At this level, the examiner wants to see evidence that you are able to take one idea and develop it effectively.

Design Portfolio: Solution

Your design solution should show your finished idea. Although you are not expected to achieve a professional finish at this level, you should aim for the best quality possible so that your idea is communicated clearly.

A poorly executed outcome will affect your final mark, so it is worthwhile taking time to plan and to select appropriate materials. You do not need to use expensive materials or processes, but if you are limited in what you can use to complete your final outcome, you should consider this at the design brief stage. This will ensure that you don't attempt something that you don't have the resources or level of skill to carry out successfully.

Effective response to the design brief	• Consider the requirements of the design brief – function, aesthetics, target audience/market, constraints • Select the most effective development idea for further refinement

Media/techniques/ technology	• Select the most appropriate materials, techniques (and construction methods if working in 3D) • Create a high level of finish

Further refinement	• Consider how the selected development will be further refined, while still maintaining visual continuity • Consider how use of the visual elements and design elements can be further refined/improved

Evidence Required

You should produce a final design solution. If you are working in 3D, your final piece can be submitted or photographs sent instead (this is sometimes more practical, especially if the piece is large scale and/or fragile).

If you are working in Product Design, Architecture/Environmental Design or Interior Design, the solution can be a prototype, concept model, or scale model.

The solution must show a strong visual link with previous development work.

COMMON MISTAKES

In Graphics and Textiles, when students are working with digital technology, they sometimes fail to further develop and refine their selected development, submitting a larger version of the idea as their solution instead.

Scaling up a development idea without making any changes is not refinement.

Marks are available for the further development and refinement of the development work. You will not be able to access these marks unless you demonstrate that you have done this.

HINTS & TIPS

SQA have to charge for the return of Art & Design work. The return of 3D work can be an additional expense. You may prefer to send good quality photographs instead. As long as the images are clear and show your work from different viewpoints, this will not affect your mark.

Design Portfolio: Evaluation

Evaluation is an important aspect of your work. It is an activity which many students find difficult. It is not always easy to be objective about your own work!

Analysing the effect of creative choices in the Portfolio
- Choice and use of design materials
- Use of techniques and/or technology
- Use of the visual elements and design elements
- Consideration of function

Critical appraisal of the effectiveness of the design solution
- Review against the requirements of the design brief
- Consider strengths and areas for improvement
- Justification of opinions

COMMON MISTAKES

When evaluating their work, students often forget to refer to their design brief. It is important that you refer directly to your design brief and explain how well you have met the requirements.

HINTS & TIPS

Keep your evaluation concise and focused – the examiner does not want to read a narrative account of your Portfolio as no marks can be awarded for description.

We recommend that you write around ten well-focused and well-justified evaluative comments. Approximately five comments should relate to the design process you followed and its effectiveness. The other comments should relate directly to the effectiveness of your design solution. Refer to the next section, as well as the case study, for advice on how you can do this.

Evidence Required

The evaluation should demonstrate that you can critically reflect on and evaluate the effectiveness of your Portfolio and design solution using appropriate terminology.

Some schools use a template, while others ask students to annotate their work. Some schools use a combination of annotation and extended writing.

There is no minimum word count, but you must address all of the assessment criteria.

Marks are awarded for well-justified, evaluative comments relating directly to the design solution.

To help you with your Design Portfolio evaluation

You should aim for your evaluation to be concise and to the point. You must demonstrate that you can identify and comment on the most important aspects of your development and final design solution. You should try to make realistic judgements about the effectiveness of your development and design solution.

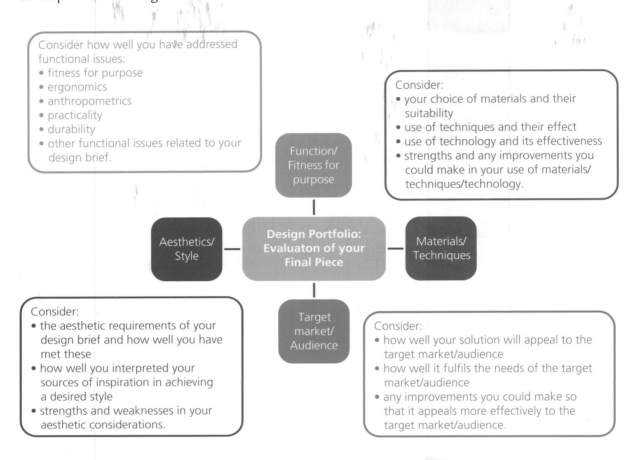

Consider how well you have addressed functional issues:
• fitness for purpose
• ergonomics
• anthropometrics
• practicality
• durability
• other functional issues related to your design brief.

Consider:
• your choice of materials and their suitability
• use of techniques and their effect
• use of technology and its effectiveness
• strengths and any improvements you could make in your use of materials/ techniques/technology.

Function/ Fitness for purpose

Aesthetics/ Style

Design Portfolio: Evaluaton of your Final Piece

Materials/ Techniques

Consider:
• the aesthetic requirements of your design brief and how well you have met these
• how well you interpreted your sources of inspiration in achieving a desired style
• strengths and weaknesses in your aesthetic considerations.

Target market/ Audience

Consider:
• how well your solution will appeal to the target market/audience
• how well it fulfils the needs of the target market/audience
• any improvements you could make so that it appeals more effectively to the target market/audience.

HINTS & TIPS

When evaluating, the following formula may help you:

Identify the issue

• make a statement or give an opinion.

Explain/Conclude

• give further detail
• justify the point
• give reasons
• make judgements
• discuss the resulting effects or decisions.

How to develop basic commentary into evaluative comments

BASIC COMMENTARY	EFFECTIVE EVALUATIVE COMMENT
I used sea anemones as a source of inspiration for my jewellery piece.	I used sea anemones as a source of inspiration for my jewellery piece. This was a good choice and resulted in a piece which has interesting textural forms in a variety of different scales. The texture combined with the colour scheme of hot pinks and oranges creates visual impact. The 'soft spikes' inspired by the form of the anemones are also comfortable for the wearer.
I was pleased with my lighting design.	I was pleased with my lighting design which turned out better than I expected. This was because I was restricted to using paper and I was concerned that this might be a bit basic. However, I investigated lots of ways of manipulating this material and my final piece was created using an origami technique combined with cutting sections away. This gave a collapsible form, which meant my design can be flat packed effectively, which was one of the design requirements.
I spent a lot of time on development and ran out of time at the end.	I spent a lot of time on development and ran out of time at the end. This means my final architectural model is a bit roughly finished. It still communicates my design solution fairly well, but I feel that more attention to detail would have enhanced the presentation and would be more appealing to my client. In future, I would realise how long it actually takes to make a highly finished scale model and set aside more time.
I used ICT techniques when I made my final poster design.	I used ICT techniques when I made my final poster design. This enabled me to create a professional looking piece of graphic design. I was able to combine the most successful typography along with my original photographic imagery in the best layout. I also layered images and made adjustments to the opacity using digital technology. The resulting design strikes a balance between having good visual impact and communicating the message clearly. The slick and sophisticated finish achieved by using ICT should appeal to the young target audience who go to festivals, as specified in my brief.

Design Portfolio: Presentation

Do	**Don't**
consider your Portfolio format and how it will communicate your creative process most effectively.	overlap your work or create fold-out sections – the examiner may not see this work.
think about using a vertical format, which tends to hang better. Horizontal formats can sometimes fold in on themselves.	feel as if you have to fill the maximum 3 × A2 sheet allocation. Quality is more important than quantity.
include your design brief so that the examiner can understand your intentions.	include unnecessary Unit work which may make your presentation confusing.
include the starting point from your Unit. This should be your selected idea which you have further developed.	include more than one line of development.
label your starting point clearly and consider using arrows or labels to make your work easier to 'read'.	print or write your evaluation double-sided. The examiner may not see the second page.
include other important information and/or visuals, such as your source of inspiration.	exceed the maximum space allocation of 3 × A2 sheets (or equivalent).

COMMON MISTAKES

Students sometimes forget to include their design brief. This makes it very difficult for the examiner to know what the design requirements are and to apply judgements about how well you have fulfilled these.

HINTS & TIPS

Try to ensure that your Portfolio can be understood by the examiner.

Labelling and brief annotations can help a great deal.

Use the checklist on this page to help you keep track of your
Design Activity and ensure that you fulfil the assessment criteria.

		Task	Success criteria	✓
DESIGN ACTIVITY CHECKLIST				
Unit	1	Starting point	I have selected a design brief which is clear and easy to understand.	
			It contains information on the functional issues of the design problem.	
			It gives me direction on aesthetics (look, style, inspiration).	
			It includes information about the target market/audience.	
	2	Investigation and research including critical studies	I have completed critical studies research showing that I have learned about a range of designers (including at least one contemporary designer).	
			From my critical studies, I have selected two designers and analysed at least **two works** by each.	
			I have completed in-depth research on my target market.	
			I have researched key aspects of my design brief, including function and sources of inspiration.	
			I have included annotations to explain my thoughts and decisions.	
	3	Development	I have completed at least two developed ideas which demonstrate different responses to my brief and are of an appropriate quality.	
			I have explored relevant materials and/or techniques.	
			I have selected the most successful idea for further development.	
	4	Evaluation	I have evaluated my Unit work and planned my next steps.	
Portfolio	5	Portfolio Development	I have produced a range of further developments based on my selected idea, adapting and refining it with reference to the requirements of the design brief and have considered materials and techniques.	
			I have added annotations to explain my thoughts and decisions.	
	6	Design solution	I have planned the production of my design solution, taking account of the time, resources and skills required.	
			I have produced my design solution to the best standard I am capable of.	
			If appropriate (for 3D work) I have photographed my design solution, or arranged for it to be photographed.	
	7	Evaluation	I have evaluated the effectiveness of my design solution, referring to the requirements of the design brief.	
	8	Portfolio Presentation	I have discussed the most suitable presentation format and style with my teacher, considering shape and size of card/paper and colour scheme.	
			I have included my design brief and Unit idea, along with any other important Unit information (such as my source of inspiration) which I have clearly labelled.	
			I have arranged my work into a suitable layout, so that the design process is clear, and checked this with my teacher before proceeding.	
			I have carefully and neatly stuck down my work, including my design solution (or photographs of my solution if 3D).	
			I have included the evaluation of my design solution in an appropriate format.	
			I have added titles/sub-headings, where appropriate, to my work so that the design process is clear.	
			The separate sheets of my portfolio have been securely taped together on the back.	
			The labels supplied by SQA have been stuck onto the back of my Portfolio.	
Well done – you've made it!				

Crochet Cells

Design
Case Study

3

DESIGN
UNIT AND
PORTFOLIO

Daniel's assessment task instructions

Daniel's teacher gave the class a brief adapted from an SQA Unit Assessment Support Pack.

Design brief: body adornment

Throughout history, people have used body adornment for different purposes – for decoration, accessorising, to convey status or wealth, or for symbolic purposes. Your task is to design a piece of body adornment.

You should consider your source of inspiration. This will influence the **style** of the item. You may select one of the following:

The Natural World:

- sea life
- plant form
- human body
- exoskeleton

The Man-Made World:

- machinery
- electronics
- architecture

As well as style, you should consider the **functional** aspects of the piece:

- purpose
- durability
- wearability
- materials
- techniques.

You should also consider the **target market** for your body adornment; who should find it appealing?

To pass this assessment, you will have to:

- select **two** designers and choose at least **two** examples of each designer's work which you find interesting and inspiring and which relate to your selected design brief
- analyse how each designer has used materials, techniques and/or technology and how their creative choices have affected their designs
- analyse the impact of their design choices and any significant social and cultural influences on their working methods and/or practice
- analyse your design brief to identify the opportunities, issues and constraints in your design brief
- produce a variety of in-depth investigative design drawings and studies, and collect examples of market research relevant to your brief and chosen design area before starting to plan how you might develop your own design ideas
- develop and refine **two of your initial design ideas**, taking account of the design brief requirements, responding to design challenges by finding creative and effective ways to realise your ideas.

All of this work should be presented in your sketchbook for assessment.

Design Unit: Initial ideas

Teacher's feedback

Daniel, your experimental drawings and prints are excellent. I like the continuous line drawing in ballpoint pen which has energy and an interesting three-dimensional quality. To move forward with your 3D work, try to create multiples of one sample to experiment with the effect of repetition. Remember to make a record of these samples by photographing them as you go along.

Daniel's source of inspiration was red blood cells. He explored the shapes and forms using a variety of different media and techniques. After working in 2D, he decided to experiment with a 3D approach by using a variety of textile materials.

Design Unit: Study of designers and design works

Daniel's teacher asked the students to select a designer from a major design movement. This designer's work was to influence their own practical work in terms of style. Daniel chose to look at the work of the historical designer Georges Fouquet who worked during the Art Nouveau and Art Deco periods. Daniel was particularly interested in the Art Deco jewellery as he thought that the red and black colour schemes and the repeating circular shapes related well to his own design inspiration of blood cells. To fulfil the requirements of the critical studies aspect of the Unit, Daniel had to select two items of jewellery to research and analyse.

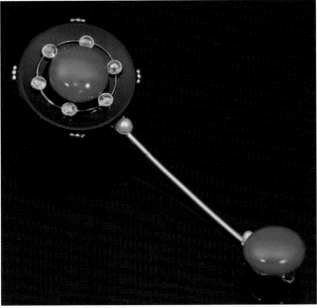

Jabot Pin (1920) by Georges Fouquet
materials: gold, platinum, diamonds, coral and onyx

Brooch (2008) by Dorothy Hogg
materials: oxidised silver and coral beads

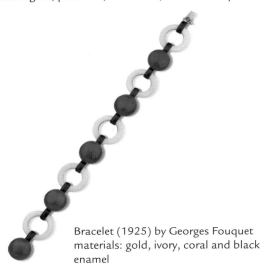

Bracelet (1925) by Georges Fouquet
materials: gold, ivory, coral and black enamel

Daniel was also asked to choose a contemporary designer whose work might inspire him. He chose Dorothy Hogg. He selected two pieces from her Artery Series to analyse for his critical studies. Looking at this jewellery gave Daniel confidence in his choice of theme. It allowed him to see how another designer had approached a similar topic using a limited selection of materials and a restricted colour palette. Daniel was inspired by the simplification and stylisation in the work. He was also impressed by the designer's ability to create stylish jewellery using lightweight silver tubing and small red beads, representing veins and blood cells.

Learning about significant designers and their working methods was a key aspect of Daniel's progression and encouraged him to approach his own work in a more creative way.

Brooch (2008) by Dorothy Hogg
materials: silver, felt and coral beads

Design Unit: Development sketches

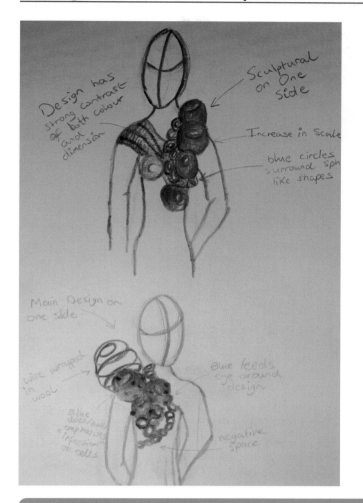

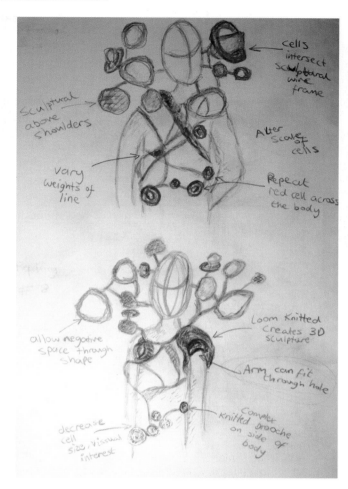

Daniel created two different lines of development. One involved crochet pieces which he linked together to fit the body closely. With his other idea he experimented with protruding and hanging elements. He enjoyed developing both concepts but felt that the crochet idea was more practical and related more effectively to his source of inspiration.

When Daniel moved from 2D into 3D techniques, he began to get really creative with his developments.

Daniel's Unit evaluation

Daniel used a template adapted by his teacher from the SQA Unit Assessment Support Pack when reviewing his Unit work. This ensured that he met the assessment criteria and did not miss out anything important. His teacher also told him that this piece of work was assessed on a pass/fail basis depending on whether he met all of the assessment criteria.

Unit evaluation: The Design Process Outcome 1 Assessment Standards 1.1, 1.2 and 1.3
Designers and their work My chosen designers and works
Georges Fouquet (Art Deco period) Pin (1920), Bracelet (1925) **Dorothy Hogg** (Contemporary) Pieces from the Artery Series 2008
Market research: What I learned about the way they used materials, techniques and/or technology
Fouquet's designs: • expensive precious metals and precious stones combined with semi-precious stones • bracelet – gold, ivory, coral, black enamel • pin – 19-carat yellow gold, coral, black onyx, rose cut diamonds, platinum. **Dorothy Hogg:** • works on a small scale using limited materials such as felt, silver, oxidised silver, silver tubing and black and red coral beads. **Both designers:** • traditional jewellery metal-working construction methods are used • pieces are constructed using multiples • complex designs are created by repeating a single shape.
Significant social and cultural influences – how these impacted on the designer and their work
Dorothy Hogg: • designer in residence at the Victoria and Albert Museum – significant influence on her Artery series of work – surrounded by many different cultural influences and would have had access to their collections • Artery Series is influenced by the human body and by medical research, made possible by modern technology • inspired by magnified images of blood cells and the way blood circulates around the body • 'liberated' during this period to make work using materials other than metal • opportunity to experiment and 'loosen up'. **Georges Fouquet:** • Modern Art influence – Cubism and Futurism influenced Fouquet to embrace the geometric form • during the First World War, mass production arrived and it was the start of the transport/machine age – inspired geometrical forms and simple colour schemes using simple motifs • another major influence on Art Deco and this jewellery was Egyptian style, as the tomb of Tutankhamun had recently been discovered.
What I have learned about the design area
• Body adornment, fashion and jewellery design are closely linked – all areas of design which concentrate on displaying and wearing your designs on the body. • Jewellery can fulfil different functions: drawing attention to a part of the body; accessorising an outfit; conveying the wearer's status, wealth or importance. • Can also be used to create visual impact, for instance in a fashion show. • There are different target markets for different kinds of jewellery. The jewellery I have been focusing on would be attractive to collectors of unusual pieces; people who were at the cutting edge of style at the time the jewellery was produced. • Jewellery designers often make sketches, and then, before creating a piece of work, will often trial their designs by making a model or three-dimensional 'sketch'.

HINTS & TIPS

Completing your Unit evaluation should help reinforce your ideas and decisions, and help you to plan for your Portfolio.

How I could use aspects of this knowledge in my own work
• Art Deco jewellery has a modern contemporary feel, specifically the geometric motifs used in multiples – I will try this technique in my own work. • Both designers use a limited colour palette and I will incorporate this in my own approach. • The use of geometric shapes that often overlapped and multiplied has inspired me to develop a more abstract approach. • Hogg's interest in the human body particularly inspired me in my exploration of red blood cells and to experiment with less conventional materials. • Hogg's ability to cleverly contrast both colour and shapes to create negative space within a design intrigued me. I want to utilise negative space. Her work inspired me to use multiples because of the complex designs, which can be created by repeating a single shape. • I really like working in three dimensions and after reading about Hogg's approach, I feel confident developing 3D 'sketches'.

Outcome 2 Assessment Standards 2.1, 2.2, 2.3, 2.4 and 2.5

My design ideas – Review and reflection The design brief – opportunities, issues and constraints
• I am going to produce a piece of body adornment inspired by the characteristics of red blood cells. • My design should be wearable and have visual impact. • I should consider suitable materials and construction techniques.

My creative choices and decisions – how I approached planning and developing my design ideas in response to the brief
• I began by researching the transportation of red blood cells around the body. • Looking at the cells in black and white forced me to look at the shape and form of a cell rather than becoming lost in multitudes of colour. • Not giving the shapes representing 'cells' in my design any colour was a significant aspect as I would imagine that in the body, the cells without life or 'without heart' have no colour.

Knowledge and skills I have gained or developed – creative challenges and opportunities and how I responded to them (design-based problem solving)
• Exploring black and white samples, the results were still too flat and uninteresting to become a final solution. • Inspired by the work of Alexander Calder, particularly his mobiles, I used momentum and balance to make the individual elements move and thus to give the illusion that they are 'floating' and not inside the body. • By looking more at the textures of red blood cells and this time in colour, my exploration took a new direction – I imagined that red blood cells possess a soft textured surface and tried lots of mini material experiments exploring different core materials. • Wool was the best choice of material due to the diversity of techniques available. After learning the basics of knitting, crocheting and weaving, I experimented with them further by combining techniques and altering the scale and weight of line while using the wool.

How my choices and decisions affected the success of my design ideas – strengths and areas for improvement in my approach
• I found my direction with materials quite early on so I was able to spend a reasonable amount of time experimenting. This let me try lots of different combinations and various construction techniques. If I came across a problem, I didn't give up, but just kept trying different variations. • One area for improvement was that I could have been more decisive – I went off on tangents at times because I got absorbed in experimenting with materials. I could have been more focused on my design brief and on how I was going to consider important design issues such as how the design would fit the body effectively and how it would balance.

Strategies for further improving and refining my design work and ideas
• I will continue to use a limited colour palette. • The large scale of the ideas I have created has thrown up some problems. Specific elements extend beyond the body and are intricately designed. This might make the final piece difficult to construct, or it may increase the risk of elements getting tangled or falling off so I will need to resolve this issue when I move on to my Portfolio.

Teacher's feedback

Well done, Daniel – this is a very full and comprehensive evaluation which meets all of the Assessment Standards.

Design Portfolio: Brief

When Daniel moved on to his Design Portfolio, he revisited his Unit design brief and refined it further. His teacher advised him to identify a specific client and to provide more detail on the rationale behind the purpose of his design.

Design brief

The Blood Transfusion Service is holding a charity fashion show to raise the profile of their organisation.

Design a piece of body adornment which will be featured in the show.

The source of inspiration should relate to the theme of the show. The style should create visual impact.

You must consider **wearability**, as well as suitable materials and techniques.

The audience will include a number of high-profile guests and also the general public, so the piece should have a broad appeal. Pieces will be auctioned to raise funds for the charity so it should ultimately appeal to collectors of unusual pieces of body adornment.

HINTS & TIPS

If you have the opportunity to write your own design brief, try to create a series of requirements and specifications which will help you to focus effectively on the design problem.

COMMON MISTAKES

On completion of their Unit, many students do not consider amending or clarifying their brief before proceeding to the Portfolio. During the Unit, it may have become apparent that a brief was too restrictive or too open-ended, or simply needed clarification. It is worthwhile taking some time to reflect on your design brief to see if there are any improvements you could make. A good brief is key to the success of your Portfolio.

Design Portfolio: Development

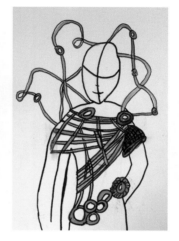

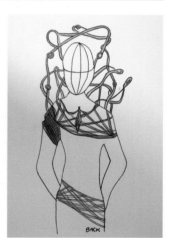

In his Portfolio Daniel decided to combine the crochet technique from his first Unit idea with elements of his more adventurous second idea. He created sketches to help him work out a layout for his jewellery piece. He also continued to make crochet samples to refine some of the techniques he had explored earlier in his Unit.

Teacher's feedback

Your 3D samples are excellent, Daniel. You now need to decide which of these samples you would like to take forward to create your final design solution. You might want to try arranging some of the samples on a mannequin to help you visualise the concepts. This will also help you to address any functional issues, such as how it will balance and fit the body. You should also consider how your design will be put on and taken off.

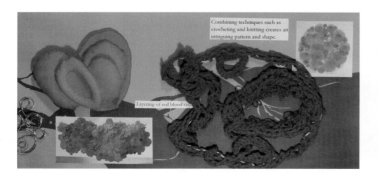

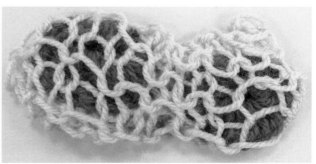

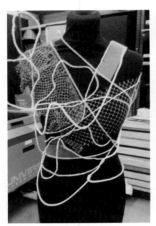
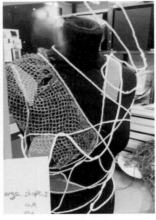

HINTS & TIPS

If you are working on 3D developments, you should take photographs as you make changes. You should not worry too much about the quality of these 3D developments as they are just to help you work out ideas which can be refined later. This is a quick and easy technique and will give you a visual record of your thought processes.

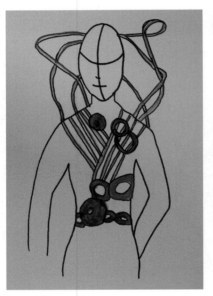
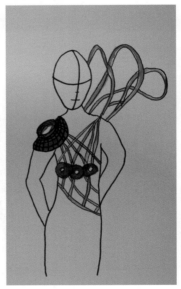
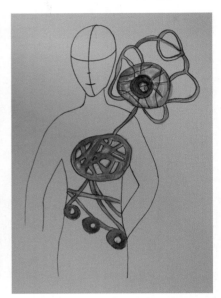

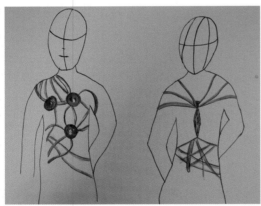

During the development of his Portfolio, Daniel decided to limit his colour palette to red and yellow to give his work more coherence. He taught himself a number of different crochet and knitting techniques and found that he could work quickly and produce multiples of the circular motifs relating to his blood cell inspiration. He also used wrapped wire to create structural elements. Daniel now felt ready to construct his final piece. However, he still had to solve the problem of how the design would be stabilised on the body. He came up with a simple solution – to attach it to a base garment made from t-shirt fabric and to create a hidden fastening on the front.

Design Portfolio: Solution

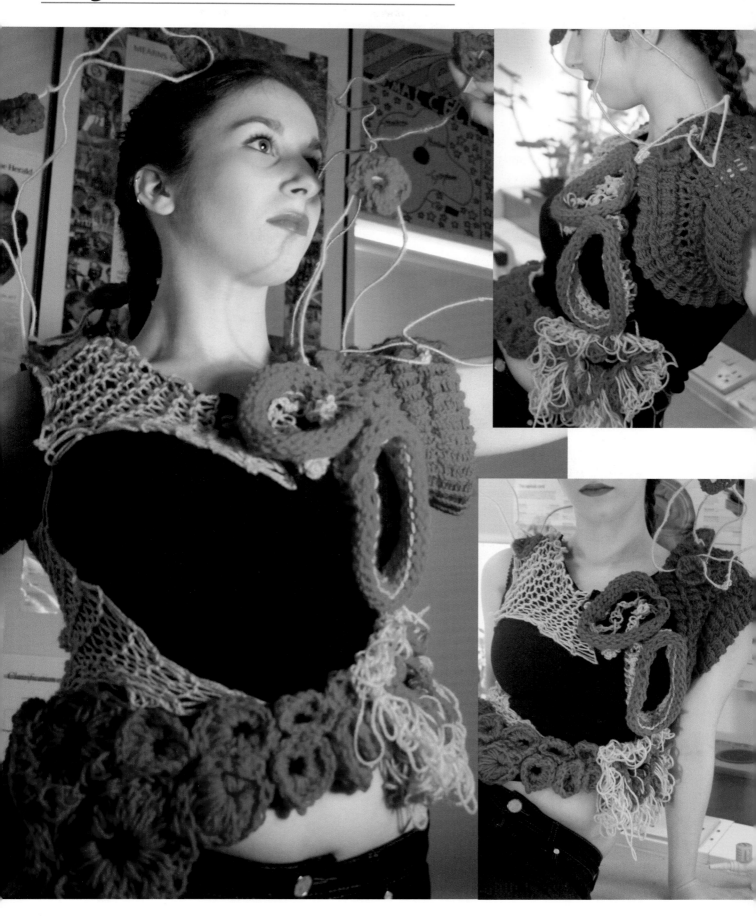

Finished Design Portfolio

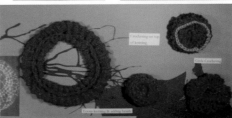

Combining techniques such as crocheting and knitting creates an intriguing pattern and shape.

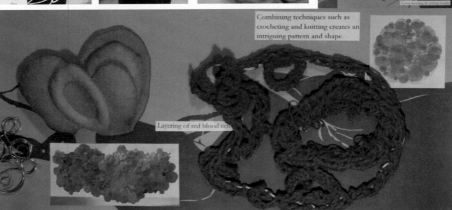

Layering of red blood cells

In my design drawings, I tried to solve the problem of how the design would fit on the body and how it might balance. The sketches allowed me to consider how I could combine some of the motifs I had developed and helped me work out how I could create the visual impact required.

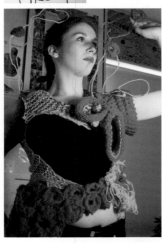
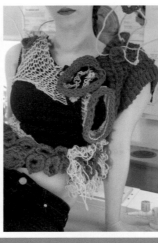

I experimented with a number of textile techniques and found that I really enjoyed crochet. The circular forms were an appropriate interpretation of blood cells. I made a variety of samples which helped me to decide on the most suitable materials and techniques to use in my final piece. The other advantage of the crochet technique was that the resulting forms were soft, lightweight and comfortable to wear.

Daniel's Portfolio evaluation

Daniel's teacher advised him to keep his evaluation short and to the point. He was reminded that he should critically reflect on and evaluate his **Portfolio and final design solution** against the requirements of his design brief. The assessment criteria were used to provide headings, and Daniel used bullet points to keep his evaluation focused.

Use of materials, techniques and technology and consideration of function

- My favourite part of the project was experimenting with a variety of design materials and techniques. I developed a variety of 3D approaches which influenced my choice of materials for my final solution. I learnt how to crochet using a limited colour palette of red and yellow wool, which related well to the blood cells theme.
- Wool was my main design material for my final solution but the decision to use this material helped me focus on the properties of the material and on form and functionality. The technique of crocheting has been largely forgotten and I had to use the technology of the internet to learn how to crochet. I was easily able to find YouTube clips, which helped me learn quickly so I could apply the techniques to my developments.
- The three-dimensional qualities of crocheting in the round inspired my final solution. I found it easy to develop a sculptural approach by pinning oval crocheted cells together in different arrangements to create developments. This allowed me to experiment with form and solve the problem of functionality and how the design would fit the body. After pinning the wool cells to the mannequin I realised that constructing the final solution in crochet alone might be problematic. I considered this issue by developing the idea of an undergarment that could slip over the body of the wearer. This allowed for a tight fit on the model/wearer and, due to the neutral colour of the undergarment, allowed the crochet elements of the piece to become the focal point.
- My design brief was to create a sculptural body adornment that had visual impact using the theme of blood cells to create a statement piece. This allowed me to use a fashion design approach in my development of the solution regarding wearability, rather than taking a jeweller's approach to functionality. This also allowed me to consider wearability while further developing the visual impact of the crochet technique.

Critical appraisal of the effectiveness of the final design solution

- I believe that I answered all the requirements of my design brief. I produced a one-off statement piece, which had effective visual impact and a focus on aesthetics inspired by the red blood cell. The issue of wearability was solved by designing a simple undergarment which had the crochet cells hand sewn onto it. I do feel that this solved the problem but if I had more time and skill level I would like to have crocheted the whole solution and I feel that this would have improved the appearance of the design.
- I was able to develop an interesting statement piece from this seemingly simple starting point. The flow of blood through the body and the repairing and regeneration of cells are all inspirations that allowed me to effectively develop the aesthetics of my design.
- I do like the contrast of texture between the wool and plain cotton but durability would be an issue if the garment were not for a one-off occasion. This is an aspect that could definitely be improved by more careful construction.
- I am delighted with the effect of my new skill of crocheting in this final solution, and I truly believe that I will continue crocheting for the foreseeable future. I like the scale of my piece and it has a very distinctive appearance, which would create the visual impact required for a fashion show as the bright colours and large-scale elements could be seen clearly on the catwalk. I feel that the blood cells inspiration is interpreted in a creative way which would attract the attention of the audience and help generate interest in the work of the Blood Transfusion Service.

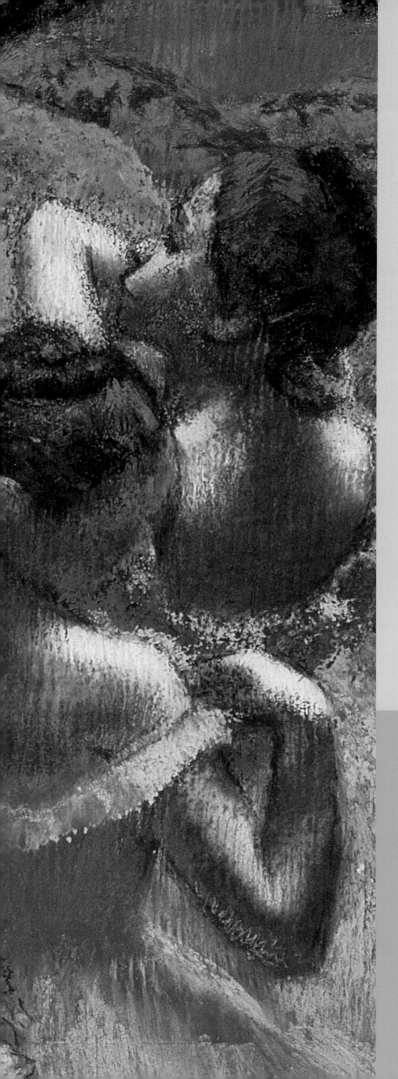

Chapter 4
The Question Paper

4 The Question Paper

Introduction and overview

The Question Paper is worth almost 28 per cent of the overall mark. This is a large proportion of your mark, so it is well worth putting in the effort to prepare for the exam to achieve the best possible result. Many students find the Question Paper challenging, but there are skills and techniques you can learn to help you to deal with it effectively. The time allocation for the paper is **2 hours.**

Section 1 Expressive Art studies
- **Q1 or Q2 –** You **must** answer **one** of these questions. You will respond to a set question with a given image. This question is designed to test your knowledge of Expressive Art practice in an unfamiliar situation.
- **Q3 or Q4 –** You must answer **one** of these questions. Your answer should be based on Expressive Art works you have previously studied.

Section 2 Design studies
- **Q5 or Q6 –** You must answer **one** of these questions. You will respond to a set question with a given image. This question is designed to test your knowledge of Design practice in an unfamiliar situation.
- **Q7 or Q8 –** You must answer **one** of these questions. Your answer should be based on Design works you have previously studied.

Structure of the Question Paper

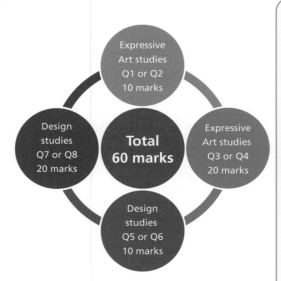

Expressive Art studies
Q1 or Q2
10 marks

Design studies
Q7 or Q8
20 marks

Total 60 marks

Expressive Art studies
Q3 or Q4
20 marks

Design studies
Q5 or Q6
10 marks

Differences from National 5

- In the N5 paper, there are mandatory Q1 and Q7 (based on what you have learned in class). In the Higher paper, there is a choice of questions in each section. However, these questions, based on what you have previously studied, are more demanding and are worth 20 marks, rather than 10. You need to demonstrate a knowledge of context which is not required at N5 level.
- There is a more limited choice of image questions. You may find that you have not studied any of the Expressive Art or Design areas in the paper. This paper requires a much wider knowledge of the subject than the N5 Question Paper. For example, you may have previously worked in jewellery and product design, but find that the paper that year only has questions on graphic design and fashion/ textile design.

Exam technique

Development of exam technique is crucial to your success in this Question Paper. The example questions and answers in this chapter should help you to build up your exam technique and learn how to respond effectively and confidently to the questions asked.

Time management in the exam

You have 2 hours in which to complete the Question Paper. You should take some time to read the paper and decide on which questions you will attempt.

Recommended time on each question		
Question	Time	Marks
Reading and deciding	max. 10 minutes	
1 or 2	15–20 minutes	10
3 or 4	35–40 minutes	20
5 or 6	15–20 minutes	10
7 or 8	35–40 minutes	20
TOTAL	2 hours	60

The longer you take to decide on the questions you will attempt, the less time you will have to answer them. Therefore, it is important to be decisive but also to decide effectively. If you practise exam style questions, this will give you an idea of the type of question that will suit you. Being able to write enough in the time given is an issue for many students. Practice will help you to speed up and to write fuller and more in-depth responses.

Preparing for the Question Paper

There are a number of techniques which will help you to prepare for the exam:

Making up your own questions and marking schemes is a very effective way to understand the format of the paper and the terminology used in questions. Get a friend to do the same. You can swap questions to test each other.

Revise the meanings of Art & Design terms and try to expand your descriptive vocabulary in general. Make up lists of definitions and use a thesaurus to come up with alternative descriptive words.

Practise, practise, practise!

Work by yourself or with a friend to mind-map or list possible responses to questions. Challenge yourself to write down as many relevant points as you can within a time limit.

Start with some basic descriptive statements and add explanations and justifications. How would you extend the point *'the designer has used organic forms'* for example?

Section 1: Expressive Art studies

There are many aspects relating to Expressive Art you may be asked to comment on. These might include:

Composition or arrangement	• arrangement; pose (in figure and portrait work) setting; viewpoint; focal point; choice of subject matter; perspective; proportion; scale and use of space
Subject matter /Imagery	• choice of subject matter; effect on the work
Possible sources of inspiration	• influences on the work – subject matter, styles; effect on the work
The visual elements	• line; tone; colour; shape; form; texture; pattern; how they have been combined/applied; their effect on the work
Media handling and techniques	• choice of media and processes; application of media; effect on style; treatment of subject matter; level of detail; expressive qualities; skills demonstrated; 2D or 3D; scale of the work; influences on technique
Style	• aims and influence of specific art movements; what makes the work distinctive; sources of inspiration; the artists' 'trademarks'; personal response to the subject
Scale	• the dimensions of the work; large or small; effect of scale on the work; effect of scale on detail/realism/visual impact, etc.
Mood and atmosphere	• the mood and atmosphere created and how this has been achieved (e.g. colour, use of media, subject matter, composition, style etc.); what the work communicates to you and why
The effectiveness/ success of the work	• your opinion on the effectiveness/success, with reasons relating to your own preferences in Expressive Art practice, visual impact, message/mood communicated, etc.
Visual impact	• effectiveness of the visual impact and how this has been achieved (e.g. colour, use of media, subject matter, composition, style etc.); how effectively the work communicates to you and why
Response to the subject	• how the artist has responded to the subject – conventional or unconventional approach: for example, techniques and methods used

Questions 1 and 2: Expressive Art studies image question

You will choose **one question** to answer from this selection. This part of the paper is all about responding to an unseen image (although you may come across an image that you are familiar with by chance). You will be applying what you have learned to the analysis of a particular Expressive Art work. The marker will expect to see that you have a knowledge and understanding of Expressive Art practice and that you are able to apply terminology correctly and effectively.

Each question in this section has a related image. These will change from year to year, but you can get an idea of the variety likely to come up by looking at SQA's Specimen and Exemplar Question Papers and past papers on their website. You can also prepare for this part of the paper by trying to broaden your knowledge of Expressive Art in general.

Although there will only be two questions to choose from, you may expect to find a variety of genres and approaches in the paper, such as:

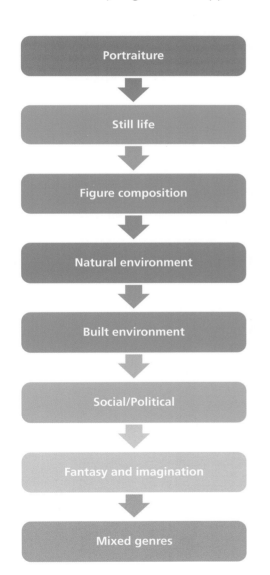

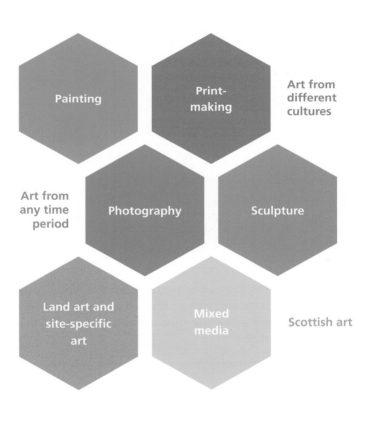

Questions 1 and 2: Structure

These questions are divided into two parts – part (a) and part (b). Part (a) is more accessible, and most students find this aspect fairly straightforward. Part (b) is designed to really challenge you, and only students who are really prepared and who are able to demonstrate a deeper level of understanding will be able to access these marks. The structure can be illustrated as follows:

(a)

Describe the use of Expressive Art *prompt (a)* 1

Describe the use of Expressive Art *prompt (a)* 2

(b)

Expressive Art *prompt (a)* 1 **+** Expressive Art *prompt (a)* 2 **=** Explain effect on *prompt (b)* 3

COMMON MISTAKES

A lot of students don't realise that you have to write about the combined effect of the two elements in the question prompts in part (a) to answer part (b) effectively. If you do not do this, you cannot be awarded marks.

HINTS & TIPS

The question prompts are always in italics, so you should pay particular attention to these words. See example on the opposite page.

To avoid your responses becoming repetitive, you should work on your use of terminology and try to broaden your descriptive vocabulary in general. Here are some alternatives for 'combined with' which may help you answer part (b):

together with	linked with	united with
in conjunction with	related to	connected with
juxtaposed with	mixed with	along with
used with	brought together with	joined with
merged with	intergrated with	amalgamated with
coupled with	in association with	incorporated with

Questions 1 and 2: Expressive Art studies – examples

Connie's response

Connie's class were learning how to attempt questions 1 and 2.
Her teacher gave the class this practice question.

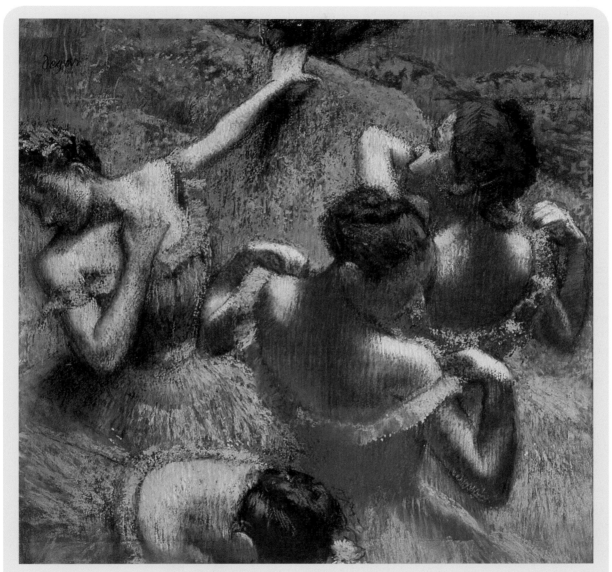

Blue Dancers (1897) by Edgar Degas
chalk pastel on paper
67 × 67 cm

With reference to the image above:

a) describe the artist's use of *composition* and *media* in this work **6**

b) explain how the artist's combined use of *composition* and *media* contributes to the effect on *mood and atmosphere*. **4**

Although she was confident in practical work, Connie did not find this aspect of the course easy. In her first attempt, she made a number of typical mistakes. Her teacher gave her some feedback to help her to improve her performance.

	Connie's first attempt
(a)	The painting is quite crowded. It looks really busy and all the dancers are crammed together. They are in different poses. The brushstrokes are visible and blue is the main colour used. Warm and cold colours are used and the colours are realistic. There are light and dark tones and this creates dramatic shadows. There is lots of texture and the painting looks rough.
(b)	The mood and atmosphere is very busy. It looks like it is backstage and they are getting ready. All of the dancers are busy adjusting their costumes. It makes me think of the excitement before a performance and the atmosphere behind the scenes.

Teacher's feedback

This isn't a painting Connie – it is a pastel drawing – always remember to read the information.

You have strayed away from the question. If you write comments that don't relate to the question then no marks can be given.

To gain marks in this part of the question, you have to discuss how the elements in part (a) have contributed to the mood and atmosphere. Although what you have said is valid, you can't gain marks unless you do this.

You need to make your response less descriptive and try to make it more detailed and analytical. We will be doing more practice to help with this.

Many of the students in Connie's class had made similar mistakes. Her teacher discussed the question with the class and they worked together to come up with a grid to help them answer the question more effectively. In their second attempts, the teacher asked the students to mirror the key words used as prompts in the question and to highlight these words in their responses. She also showed them the (a) 1 + (a) 2 = (b) formula and explained about 'joining' words to help them answer part (b).

Part (a) 1 Composition	Part (a) 2 Media	(a) 1 + (a) 2 = (b) Combined effect on mood and atmosphere
Square format. Cropped – 'snapshot' style. Limbs and faces are cropped	Pastel – quick medium – sketchy	Capturing a moment
Elevated viewpoint – viewer's eye led around the scene	Intensity of pigment applied – vibrant intense colour	Viewer is looking down on the scene rather than feeling like a part of it – candid mood created – dancers are not aware of being watched
Naturalistic poses – all are facing away from the viewer. One is bending down and her face is out of view. Diagonal of dancer's arm	Directional marks – add interest and texture. Textures are soft Colours are left unblended but a full tonal range is achieved which although impressionistic creates a sense of form and realism	Busy atmosphere – dancers appear to be getting ready. Application of media suggests the direction of light and strong shadows which add a dramatic mood Sense of excitement and anticipation Energy and movement
Crowded – figures overlapping	Dark pastel lines are applied to emphasise edges and give definition	Sense of each dancer being in her own world – each is preoccupied with her own preparation

Connie now understood the requirements of the question and felt much more confident about making a response. By approaching the question in this way, Connie found that she was even able to come up with some new points of her own. She began to remember all of the terminology she had learned in class and was able to make her answer more focused and more effective. She produced a redraft and handed it in to be marked.

	Connie's second attempt	Marks
(a)	The composition of this painting is arranged in a square format. Together with the 'cropped' effect, it results in an unusual 'snapshot' style arrangement. Limbs and even a dancer's face are cropped out.	✓
	The composition is seen from an elevated viewpoint. The dancers are crowded and overlapping one another and it is easy for the viewer's eye to be led around the scene from this almost bird's eye view.	✓
	The dancers are arranged in naturalistic poses within the composition. All of them are facing away from the viewer. One is bending down and her face is out of view. One dancer's arm forms a diagonal line, which leads your eye down into the composition.	✓
	The three dancers in the foreground are also arranged in a diagonal line in the composition, which helps suggest perspective and depth.	✓
	Pastel is a medium which is useful for producing sketches like this one. It is easily portable and as it is a dry medium it is more convenient for the artist to record scenes quickly, like this backstage arrangement of dancers.	✓
	As pastel is the chosen medium, and it has an intensity of pigment, this has given the drawing a vibrant quality. Degas has applied unblended warm and cold colours to create the blue of the dancers' costumes contrasting with the warmer skin tones.	✓
	The directional marks typical of this medium add interest and texture and the marks are left unblended and visible. The medium has enabled Degas to achieve a full tonal range from very light to very dark creating shadows and highlights which show form.	✓
	The medium is soft and chalky and has produced a scene, which is impressionistic, but still creates a sense of form and realism.	✓
	As this medium can give fuzzy edges, dark pastel lines have been applied to emphasise the edges and give definition.	✓
		6
(b)	The viewpoint combined with the impressionistic application of media means that the viewer is looking down on the scene rather than feeling like a part of it so a candid mood is created – dancers are not aware of being watched and the artist is capturing a moment in time.	✓
	The application of media suggests the direction of light and strong shadows which together with the crowded, cropped composition adds a dramatic mood.	✓
	The naturalistic poses in the backstage setting juxtaposed with the textural mark-making helps create a busy atmosphere – the dancers appear to be getting ready and there is a mood of excitement and anticipation.	✓
	The overlapping, crowded composition in conjunction with the dark pastel outlines helps to define each dancer. There is a sense of each being in her own world – each dancer seems to be caught up with her own preparation.	✓
		4
		Total: 10

Teacher's feedback

Connie, this is an excellent response and you have understood the technique of answering these questions. All of your points are explained very well. You have even exceeded the maximum marks allocation (indicated by the green ticks). You have answered part (b) effectively, and this is very challenging.

When you do your next example, use a grid as a stepping stone to constructing your response. You will find with further practice, it then becomes 'automatic'.

Well done!

HINTS & TIPS

Even if your teacher does not supply you with example image questions, you can still practise with SQA past papers and with the examples in this book.

Another useful technique is to get together with a friend and make up questions to test each other – try to find the most challenging images!

COMMON MISTAKES

Many students assume that there will be a painting in the Question Paper. This is not guaranteed. Even if there is a painting, it may be in a style you have never encountered before.

Josh's response

As there are only two questions to choose from in this section, choice is very limited. It is important that you practise questions containing images with unfamiliar genres, media and styles. If you do this you will be much better prepared to deal with whatever you come across in the exam.

Josh's teacher gave them regular homework containing a range of images, including sculpture, photography, painting and print-making so that the class were used to answering on unfamiliar topics. The following question is one example.

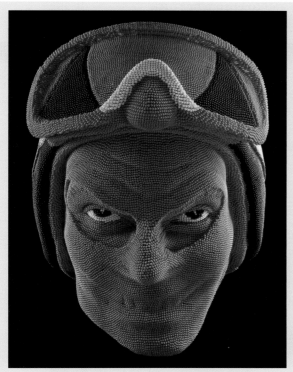

Devil's Head (2007) by David Mach
materials: matches and glue
53 × 30 × 30 cm

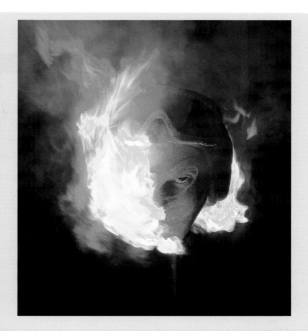

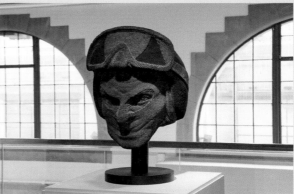

Sculpture after burning

With reference to the image above:

a) describe the artist's use of *media* and *form* in this work **6**
b) explain how the artist's combined use of *media* and *form* contributes to the effect on *visual impact*. **4**

Question (a) 1 Media	Question (a) 2 Form	(a) 1 + (a) 2 = (b) Combined effect on the visual impact
Rough Regular pattern Repetition	3D Larger than life Facial features and expression	Detail combined with larger than life form attracts attention
Tactile	Full portrait head/sculpture	Unusual material and approach to portraiture attracts the viewer
Inflammable	Unconventional	Drama of the piece going up in flames Conceptual aspect – attention grabbing Symbolism and connotations Thought-provoking
Limited colour Change of colour	Stylised Wearing goggles	Caricatured – emphasised by colour Eyes as focal point

After making some notes in the table on the previous page, Josh decided to use sub-headings to help structure his response and to ensure he stuck to the question asked.

	Josh's response	Marks
(a)	<u>Use of media</u>	
	The texture of the head is unusual because of the medium used to construct it. The match heads give a rough appearance to the skin of the head.	✓
	The repetition of the matches creates a regular pattern which reminds me of comic book Pop Art portraits and communicates a mood which doesn't seem very serious.	✓
	There is a tactile quality to this head because of the bumpy texture. The light is focused on every single match head emphasising the individual form of each single match head – you want to reach out and touch them, even though they are flammable. This gives an element of danger to the piece.	✓
	The materials mean that the artist's colour palette was limited to the colours in which matches are available. This gives the sculpture its distinctive red, yellow and black colour scheme. The burning of the sculpture transforms the striking colour scheme to monochrome greys, which gives the piece a completely different mood.	✓
	This irregular texture enhances the facial features because you are curious to see how the artist constructed the head and you will look more closely to understand the methods and materials the artist used.	✓
	<u>Form</u>	
	The 3D piece can be viewed from different angles. The head is represented 'larger than life' which will make a strong statement in a gallery.	✓
	The facial features are created with great skill and patience. You can visibly see the form of his wrinkles, nose, mouth and hairline that demonstrates the artist's skill level and ability as a sculptor. The way the features are formed creates shadows which emphasise the expression.	✓
	The expression looks evil, with a sinister grin. The form is concentrated on the head and there is no supporting neck and shoulders as might be seen in a conventionally formed portrait sculpture. This gives the illusion of the head floating in space and adds to the sinister quality.	✓
	The form of the devil is unconventional – he does not have horns as you might expect. Instead, he is wearing goggles with a flat pattern resembling horns, which intrigues the viewer.	✓
		6

(b)

Use of media combined with form and the effect on visual impact

The level of detail created by repetition of a single material, combined with the larger-than-life form, attracts attention and creates visual impact. The viewer is immediately attracted to the large head form and then realises it is constructed in a very unconventional medium which invites closer inspection. ✓

The caricatured form of the devil, emphasised by the basic colour palette of the matches as the main medium, creates the idea of the devil as a comic book villain. This will be visually appealing to viewers of all ages. ✓

The choice of the yellow matches for the eyes in conjunction with the form which suggests a mask with holes for the eyes is being worn, serves to accentuate this area. This makes the eyes particularly visually striking and the focal point of the piece. ✓

The flammable nature of the medium coupled with the devil form and the symbolism that suggests means that the viewer will be captivated by the piece and the symbolism of hellfire. The drama of the piece going up in flames adds to the visual spectacle. ✓

The transformation of the material after it has been burnt, along with the fact that the form remains intact, makes this visually a very thought-provoking piece for the viewer. ✓

4

Total: 10

Teacher's feedback

Josh, this is a well-structured and very insightful response. You are getting really confident at answering the image questions. Your range of descriptive vocabulary is excellent, which is helping you to respond very effectively.

The use of sub-headings is helping you to stay on track.

HINTS & TIPS

When answering part (a) you do not have to make three points on each prompt. You may have more to say about one element than another. As long as you make at least one valid point and make up the rest of your response with comments on the other prompts, you can still gain the full 6 marks available.

COMMON MISTAKES

When first attempting part (b) of these questions, many students don't realise that they have to link the two elements in part (a) with their effect on the element asked about in part (b).

Joanna's response

Joanna chose to work on painting for her Portfolio and studied paintings in her Expressive Art Unit. However, she realised that a painting may not come up in the Question Paper. Joanna and her friend Georgia wrote questions to test each other. They challenged each other to find images which were not 'easy'. This is a question which Georgia wrote for Joanna.

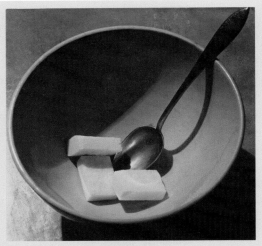

Bowl with Sugar Cubes (1928) by André Kertész
Silver gelatin print – black and white photograph
Copyright: © Estate of André Kertész

With reference to the image above:

a) describe the artist's use of *composition* and *tone* in this work **6**

b) explain how the artist's combined use of *composition* and *tone* contributes to the effect on *mood and atmosphere*. **4**

At first glance, Joanna thought she wouldn't be able to answer this question, but after using the grid technique, she could see that there was quite a lot that she could comment on.

Question (a) 1 Composition	Question (a) 2 Tone	(a) 1+ (a) 2 = (b) Combined effect on mood and atmosphere
Bird's eye view Aerial view	Black & white Monochromatic	Sombre
Angular/diagonal Leading lines	Strong shadows Directional light source	Dramatic
Geometric Rectangular/ circular	Full tonal range Tone suggests form	Narrative – story behind the scene
Square format cropped	Reflection Highlights/cast shadow	Simplicity/tranquillity

	Joanna's response	Marks
(a)	• André Kertész has used the medium of photography to portray a simple still life. This photographic composition is simple but the unusual perspective adds interest. The viewpoint is a bird's eye view which emphasises the circular form of the bowl.	✓
	• Kertész has used a square format composition to contain the three objects of the bowl, teaspoon and sugar cubes. This accentuates the geometrical aspects.	✓
	• He used the spoon to direct the viewer's eye into the centre of the bowl, which contains the three sugar cubes creating a focal point in the composition. The three sugar cubes at the focal point are repeated to stress their importance.	✓
	• The photographer has used a monochromatic palette of grey scale tones that communicates the form of the objects. This emphasises the different textures, such as the smooth bowl and the rough background of the table.	✓
	• The direction of light appears to be from the top left and this creates the curved shadow of the spoon accentuating the centre of the bowl and adding hard tonal shadows and highlights.	✓
	• A full range of tonal values is evident in this still life. The photographer has carefully lit the sugar cubes, which being white, become the lightest objects and the focal point of the photograph.	✓
		6
(b)	• The aerial viewpoint combined with black and white photography creates a sombre atmosphere created through the use of tone as the key visual element.	✓
	• His use of light creates strong dark tonal shadows in the bowl which helps emphasise the circular motif in the composition. Together these elements create a dramatic mood.	✓
	• The photographer uses the leading line of the spoon which creates a diagonal (a common compositional technique) to focus your attention on the tonally bright sugar cubes. The visual contrast between the geometric forms of the cubes is the opposite to the curvature of the bowl, which creates a tension in the mood of the photograph.	✓
	• Kertész crops the composition into a square format and frames the objects slightly off centre. The dramatic light and shade enhances the simplicity of the composition. This gives the image a tranquil atmosphere which is in contrast with the tension achieved by the geometric elements of the composition.	✓
		4 **Total: 10**

Peter's response

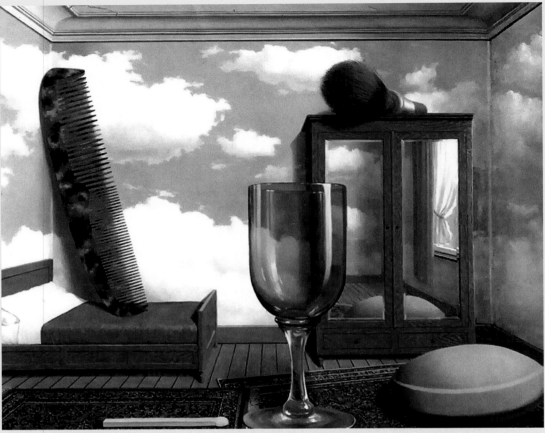

Personal Values (1928) by René Magritte
oil on canvas
80 × 100 cm

With reference to the image above:

a) describe the artist's use of *colour* and *scale* in this work **6**
b) explain how the artist's combined use of *colour* and *scale* contributes to the
 mood and atmosphere of the painting. **4**

At this level, you are expected to make in-depth comments. Although you
are asked to 'describe' in part (a), if your responses are too simplistic, you
will not gain marks. In his first attempt Peter found it difficult to give the
level of detail and justification required.

Peter's first attempt	
(a)	In this painting, there is realistic use of colour. There are warm and cold colours. Colour is used to create pattern. It is almost like a photograph. Pattern is created through use of colour. There is a mismatch between the scale of the objects and the scale of the room.
(b)	The mismatched scale along with the contrasting colours creates a strange mood. The scale and placement of objects creates tension. The realistic colour makes the scene believable.

Teacher's feedback

Peter, you seem to have run out of steam a
bit on this response. What I would like you
to do next is to take what you have written
and try to extend each comment so that you
are adding further explanation or justification.
Remember to use your thesaurus to help you
with vocabulary.

You will need to add to part (b). Once you have
worked on part (a), use the (a) 1 + (a) 2 = (b)
formula to help you complete part (b).

This should help you to get used to the level
of detail you need to give. Keep practising – it
will get easier!

	Peter's second attempt	Marks
(a)	In this painting, there is realistic use of colour. The artist uses naturalistic colours and conventional painting techniques to give the objects an illusion of 3D. He does this by using the colour tonally to create shadows and highlights and to suggest form.	✓
	There are warm and cold colours. The cool blue in the background is used as a receding colour to help the warmer coloured objects appear to come forward. The wall is painted a sky blue. This is reinforced further through the painting of white clouds. This gives the painting a strange inside/outside feeling.	✓
	Colour is used to create pattern and this is an important element in the painting, from the repetition of the white clouds on the blue sky to the detailed red and gold pattern on the rugs which help to give the scene perspective.	✓
	It is almost like a photograph as the colour is applied with a lot of care and attention to detail and none of the brushstrokes are visible. Pattern is created through use of colour.	✓
	There is a mismatch between the scale of the objects and the scale of the room. It looks like a room where the objects are larger than real life. It looks like a normal room with giant objects or a doll's house with normal sized objects.	✓
	Although the scales of the two elements don't match, all of the household objects are in proportion to each other. The furniture is also in proportion to the room, so it looks like two different paintings, a still life and an interior of a bedroom, have been blended together.	✓ 6
(b)	The mismatched scale along with the realistic colours creates a strange mood. The scene looks realistic, but cannot be real. It creates a surrealistic mood.	✓
	The scale and placement of objects combined with the naturalistic representation of colour creates an atmosphere of tension because the viewer tries to make sense of the image, but is unable to. For example, the comb is shown as being larger than either the bed or the wardrobe. The very realistically depicted everyday objects of a glass, shaving brush, comb, match and rubber are completely the wrong scale in relationship to the bedroom interior.	✓
	The unusual scale of the comb and shaving brush creates two visual perspectives using the objects to lead your eye around the painting while maintaining the accurate perspective of the bedroom. This together with the indoor/outdoor atmosphere created by the blue sky and its white clouds give a dreamlike atmosphere.	✓
	Magritte uses the contrast of hot and cold colours and the receding blue of the background to focus your attention on the scale of the everyday objects within the interior communicating a mood of unease.	✓ 4 Total: 10

Teacher's feedback

I know this was hard work for you Peter, but this attempt is much more successful. Although it took you a while to sort it out, you will find you will get much faster with further practice.

Start to test yourself against the clock and aim to complete these responses in 15–20 minutes so that you can complete the Question Paper within the time given.

A great improvement – well done!

HINTS & TIPS

Quite often students write answers which are very short or lacking detail, just like Peter's first attempt. The only way to get better at these responses is through practice and getting feedback. It may be demoralising to get the marks back for your first attempts, but if you persevere, you should see a big improvement in your performance.

Questions 3 and 4: Expressive Art studies essay question

You will choose **one question** to answer from this selection. This part of the paper is all about demonstrating knowledge and understanding of Expressive Art practice through discussion of works you have previously studied. You will be expected to show that you can apply your knowledge and understanding in response to an unseen question.

Questions are structured so that a number of different approaches can be taken. This is to reflect the variety of topics and methods which schools use in the teaching of the Expressive Art studies element of the Unit. For example, you could respond to a question by discussing one work of art, or many works of art. You may focus on the work of one artist, two artists or even several artists.

Questions change from year to year, so you cannot predict which Expressive Art elements you will be asked to comment on. However, one element of the question remains unchanged: you will **always** be asked to comment on the social, cultural and/or other influences on the work(s) you have selected.

To help you understand the format, read through this section, along with the examples.

Questions 3 and 4: Structure

These questions are divided into two parts – part (a) and part (b). Part (a) will change from year to year. Part (b) will remain unchanged, so you should find that you can prepare for this part of the question. The structure can be illustrated as follows:

(a) Select Expressive Art work(s) that you have studied

Discuss Expressive Art prompt 1 and/or Expressive Art prompt 2 **with reference to the selected art works**

(b) Explain the influence of social, cultural and/or other factors **with reference to the art works selected in part (a)**

HINTS & TIPS

The wording of the question means it is acceptable to answer on only one of the elements in part (a), if this is more appropriate to the art works selected.

COMMON MISTAKES

Many students don't realise that you must write about the selected art work(s) from part (a) in part (b). You cannot suddenly introduce new works.

Some students fall into the trap of discussing social and cultural influences very generally in part (b). If you do this, you cannot be awarded marks. Comments must relate directly to the art work(s) selected in part (a).

HINTS & TIPS

Carefully selecting art work(s) which lend themselves to most elements of Expressive Art that you could be asked about in part (a) means that you can prepare thoroughly for part (b) which is relatively predictable.

Questions 3 and 4: Expressive Art studies essay question examples

Marcie's prelim response

Marcie had studied Claude Monet and John Piper in class. Despite revising before the exam, her answer was not particularly effective; like many students attempting these questions, she made a number of mistakes that affected her mark.

This was the question which was asked in her prelim exam, followed by her response.

Answer this question with reference to any art works you have studied.

a) Discuss the artist's(s') use of *subject matter* and/or use of one significant *visual element* in the art work(s). **10**

b) Explain the influence of *social, cultural* and/or *other factors* on any of the art work(s) discussed. **10**

	Marcie's prelim response	Marks
(a)	Art works which I have studied are Monet's Rouen Cathedral Series (1894) and St Matthias, Stoke Newington, London (1964) and South Lopham (1976) by John Piper.	
	The works share a common subject matter which is cathedrals and churches. Monet's works feature Rouen Cathedral at different times of the day and in different lighting conditions. John Piper's work features churches and I have chosen two prints of two different churches in England. Monet's paintings focus on one aspect of the façade of the building, whereas Piper shows more of the building in his compositions.	✓
	A key visual element used by both artists is colour. Monet uses a colour palette which does not include black. Instead he used complementary colours to create shadows and to show the effect of the changing light on the façade of the cathedral. For example, one painting from mid-morning is predominantly warm colours and then when the light changes in the evening, the colours become mainly blues to show the cooler light.	✓
	Piper's work used black and red in the South Lopham print and a monochromatic colour palette in the print of St Matthias. This use of this colour palette makes his prints dark and atmospheric.	✓
		3
(b)	Claude Monet was the key member of the Impressionist art movement. They aimed to capture the changing light of a fleeting moment in time. They were influenced by the science of light and the discovery that white light was made up of all the colours of the spectrum, so that what you see is the light reflected from objects.	
	The Impressionists were influenced by the Industrial Revolution, as the expanding railway network allowed them to visit different places.	
	The invention of metal tubes for storing paint meant that artists could paint outside the studio with oils for the first time.	
	Scientific discoveries in the field of chemistry meant that new pigments became available, which created new vibrant colours for the Impressionist artists.	
	The Impressionists were also influenced by the introduction of photography which changed the way artists looked at the world and encouraged cropping, unusual perspectives and unconventional compositions.	
	John Piper was influenced by the Second World War. He was influenced by his time as a war artist (1940–42). He had been commissioned by the government to document the war through art. Britain was commissioning young artists and allowing them to express themselves individually, while Germany was suppressing artistic freedom. Piper sketched bombed out scenes of buildings, using his sketchbook like a camera.	
		0
		Total: 3

Teacher's feedback

Marcie, I realise you will be very disappointed with this mark as it is clear that you have studied. The problem is your exam technique:

In part (a) you have run out of things to say because you have focused too tightly on the question. You can expand your points on subject matter and colour by discussing the effect on other visual elements and other aspects, e.g. mood and atmosphere. You can also discuss how colour is applied in each work and display your knowledge of media and technique – as long as your comments relate to subject matter and colour, you will be able to pick up marks.

In part (b) you have discussed the influences on the artists, rather than the works, so no marks could be awarded. We will go over this in class as others made the same mistake. I would then like you to redraft this response as a homework task so that I can check if you have understood what to do.

	Marcie's redrafted response	Marks
(a)	Art works I have studied are Monet's Rouen Cathedral Series (1894), and St Matthias, Stoke Newington, London (1964) and South Lopham (1976) by John Piper.	
	The works share a common subject matter which is cathedrals and churches. Monet's works feature Rouen Cathedral at different times of the day and in different lighting conditions. Monet's paintings focus on one aspect of the façade of the building, whereas Piper shows more of the building in his compositions.	✓
	Monet would become obsessed about a single subject, such as the cathedral, and painted a number of canvases at the same time, swapping them around as the weather conditions changed. In some ways, Monet's subject was not the cathedral itself, but the changing light on its façade.	✓
	Inspired by his earlier paintings of Coventry Cathedral during the Second World War, Piper returned to the subject of churches throughout his career, and I have chosen two later prints of different churches in England.	✓
	A key visual element used by both artists is colour. Monet uses a colour palette which does not include black. Instead he used complementary colours to create shadows and to show the effect of the changing light on the façade of the cathedral. He often uses cooler colours in the shadows to contrast with the warm colours of the stonework. The cool blues and lilacs create a receding effect and suggest depth. Although these are not detailed paintings, the coloured shadows help to suggest detail in the stonework.	✓
	The changing colour palettes help Monet to capture the time of day and atmospheric conditions. For example, one painting from mid-morning is predominantly warm colours and then when the light changes in the evening, the colours become mainly blues to show the cooler light.	✓
	In the Rouen Cathedral series, Monet applied colour straight from the tube, in short dabs, juxtaposing the colours together. He scumbled the colours applying thin, broken layers of paint allowing layers of colour to show through. Monet built up texture through his brushstrokes, which varied from thick to thin.	✓
	Piper applied colour using print-making techniques which give his works a different quality from Monet's. Through lithography and screen-printing, he applied colours in energetic mark-making captured by the printing process. Although, he could create multiple copies of the prints, the application of colour gives these works a sense of energy.	✓
	In Piper's prints colour is not used 'realistically' but is applied to emphasise areas of the buildings and to help create structure. Although the prints are 'sketchy' the dark colours create tone and communicate a structure.	✓
	Piper's works have restricted colour palettes. Black and red is used in the South Lopham print. The dark colour in the background creating negative space helps the viewer focus on the building. The patchy colour and dabs of red give the work energy. A monochromatic colour palette of browns and creams is used in the print of St Matthias. His colour palettes and the gestural way the colours are applied make these prints dark and atmospheric.	✓ ✓
		10

(b)	The Impressionists were influenced by the work of landscape painter Eugene Boudin. In previous times, artists would sketch outdoors and then return to their studios to produce more finished works. Boudin worked 'en plein air'. This influence encouraged Monet to complete works on location. Rouen Cathedral was painted from the open window of the hotel opposite.	✓
	As a key member of the Impressionist movement, Monet aimed to capture the changing light of a fleeting moment in time. The Impressionists were influenced by the science of light and the discovery that white light was made up of all the colours of the spectrum, so that what you see is the light reflected from objects. In the Rouen Cathedral series, Monet was inspired to paint the light reflected from the façade at different times of the day and in different weather. His technique of juxtaposing colours resulted in 'optical mixing'. This meant that up close, the paintings resemble a confusing arrangement of brushstrokes, but when the viewer steps back, the colours mix in the eye and the scene is revealed.	✓ ✓
	The Impressionists were influenced by the Industrial Revolution, as the expanding railway network allowed them to visit different places. Travel was becoming more common and cheaper. This made it relatively easy for Monet to travel to Rouen and spend time painting this series.	✓
	The invention of metal tubes for storing paint meant that artists could paint outside the studio with oils for the first time. Monet was able to pack up his equipment and travel to different locations, including Rouen, to produce this series of paintings.	✓
	Scientific discoveries in the field of chemistry meant that new pigments became available, which created new vibrant colours for the Impressionist artists. This gave the Rouen Cathedral series a vibrancy and he was able to use new pigments, such as ultramarine, which he used to create cool shadows on the façade.	✓
	The Impressionists were also influenced by the introduction of photography which changed the way artists looked at the world and encouraged cropping, unusual perspectives and unconventional compositions. This influenced Monet's composition of Rouen Cathedral which is cropped in to concentrate on one aspect of the façade. In certain paintings of the series, this creates an abstract effect when all of the detail seems to have dissolved in certain lights.	✓
	John Piper was influenced by the Second World War. He was influenced by his time as a war artist (1940–42). He had been commissioned by the government to document the war through art. Britain was commissioning young artists and allowing them to express themselves individually. Piper was able to develop his distinctive style, seen in these prints of churches while he sketched bombed out scenes of buildings, using his sketchbook like a camera. He had to work quickly in these conditions. Even when there was no longer any urgency to finish his work, this experience influenced his style. Piper continued to complete quick sketches, full of movement, before developing these into the prints of South Lopham and St Matthias which retain the gestural mark-making of his original drawing.	✓
	There were also cultural influences on Piper's work. It was during the war that Piper first produced work based on a cathedral – the bombed ruins of Coventry Cathedral. This religious building destroyed by the war gave Piper a lifelong interest in churches and cathedrals.	✓
	Piper was influenced by various print-making techniques. The lithography used in the print of St Matthias is a traditional process, but scientific developments in photographic screen-printing in the 1960s and 1970s influenced Piper to experiment with this technique in the South Lopham print. Both techniques enabled him to capture the energy of the mark-making from his sketches.	✓
		10
		Total: 20

Questions 3 and 4: Expressive Art studies essay question: Fiona's study technique

There are many different ways of preparing for this question which are equally appropriate. Comparative approaches can work well, and there are examples in this book. However, Fiona's teacher advised her to simplify her approach and focus on one painting, but to study it in depth. This was because one of the art works she had studied had enough scope individually to allow her to answer these questions fully and to demonstrate her knowledge and understanding effectively.

Fiona's study matrix for *Guernica* by Picasso

Fiona decided to focus on *Guernica*, which she had found fascinating when she had studied it in class. When first writing about this complex painting, she found it difficult to separate out material which could be used in part (a) and part (b). Creating a study matrix helped to organise the material. She could then clearly see which points could be related to each aspect of the question.

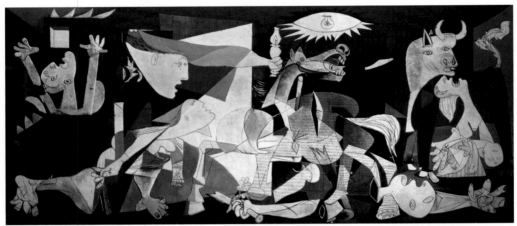

Guernica (1937) by Pablo Picasso
oil on canvas
3.49 × 7.76 m

Study matrix: *Guernica* by Pablo Picasso, 1937 (3.49 m × 7.76 m)	
Part (a)	Expressive Art issues
Imagery/Subject matter/Symbolism/ Sources of inspiration This material could also be used in part (b) if these elements aren't in part (a)	• The bombing of the town of Guernica during the Spanish Civil War and the destruction caused. The painting contains anti-war imagery. • The bull, said to represent General Franco, who had ordered the bombing. • Horse – represents the ordinary working people who were murdered and wounded. • Screaming mother and dead child. • Fallen soldier with the broken sword – represents the fallen Republican army who did not have the weapons they needed to fight back. The soldier's severed arm grasps a small flower – a symbol of hope. • Exploding light bulb illuminates the rest of the figures, highlighting the victims of war. The light also resembles an 'eye' which could symbolise the world watching the event. • Burning buildings communicate the scale of the devastation and emphasise the harmful force of war. • Newspaper print pattern (vertical marks on the horse) shows how Picasso found out about the bombing in the French newspapers. • Woman carrying the lantern, commonly known as the 'light bearer', could symbolise the battle for good and evil in the Spanish Civil War and the light of hope.
Composition	• Divided into exterior (left side) and interior (right side). Central point of the painting is the lantern being carried by the light bearer. • Multiple viewpoints are created by overlapping figures and shapes with no obvious horizon line – this distorted perspective means that everything seems to be happening on the same plane. Although the perspective is flattened, some depth is suggested by the overlapping figures and geometric shapes. • The triangular composition creates a strong diagonal emphasis. At the apex is the 'eye' and this leads the viewer's eye down to the woman on her knees. The triangle is illuminated by the use of light shining from the lantern carried by the light bearer. • The composition is fragmented in the Cubist style. It is crowded and chaotic and communicates the confusion of the scene.

Line	• Line is an important element, with jagged lines and sharp edges and angles which emphasise the triangular composition. This is in contrast to the use of curved fluid lines, which Picasso used to portray the central characters of the event. Black lines are used for simple details, such as facial features, which communicate the horror of war. Black is also used in outlines which define edges. • The buildings are linear and create a simple but distorted perspective. • The repeated dashed lines create the pattern of newsprint. • The simplicity of the marks expresses the horror of a war in a more intense way than traditional methods.
Colour	• The neutral monochromatic palette is grey and black. The 'white' is actually a light grey. • The neutral colour palette emphasises the fractured composition through his use of contrast between light and dark coloured areas. • Picasso used this monochrome palette to emphasise the horrors of war and the seriousness of the subject matter he portrayed. • It could also be a reference to the newspaper article where Picasso first learned of the atrocity in Guernica as the vertical marks on the horse are often seen as a representation of newspaper columns and words. Newspapers and their black and white photographs were the major source of information at this time. • The sharp contrast of black and white across the painting's surface creates dramatic intensity. • Absence of colour creates a sorrowful and tragic atmosphere conveying the suffering of war.
Tone	• Black and grey tones in areas of mostly flatly applied paint (unbroken by texture or tonality). • In some areas/figures, he added dark to light gradients and outlined many objects with black for emphasis. • Strong contrast of light and dark; deliberately avoids using colour so as not to detract from the dark despair of the subject.
Texture	• Textured pattern (mark-making) creates the illusion of newsprint. • There is some rough expressive brushwork in certain areas which contrasts with the flatness of the rest of the shapes. • Texture is kept to a minimum in this work of art which is common of the Cubism style.
Pattern	• The repeated dashed lines create the pattern of a newspaper column and geometric repeat rectangles are painted using a simple line to create the pattern of brickwork. • Picasso also creates pattern through the use of repeated triangles which create a jagged edge to the eye and the flames.
Shape	• Repeated triangle shapes throughout the painting. • Repeated triangular shapes create a jagged and angular pattern that pierces the overlapping figures symbolising death and the horrors of war. • The shape of the bull is transformed into a flame symbolising the flames of the burning town. • The sharp tongues of the grieving women, bull and horse are shaped like daggers symbolising screaming in rage or portraying the agony of death. • The triangular shapes create a sense of distance, space and movement which is helped by the white faces creating focal points and the dark black receding into the background giving the painting a dark and sinister atmosphere.

Form	• Form is flattened as the perspective is on one plane with multiple viewpoints. • Forms are represented from different angles – faces are simultaneously side profile and facing forward. • Tone is used to suggest form and depth. This is achieved through light and dark shape and through the application of graduated tone in rough brushwork in certain areas, such as the horse's neck.
Media handling/ technique	• Grisaille paintings are produced in monochrome. Renaissance artists were trained to produce this technique. Grisaille was less widely used in the twentieth century. Picasso's *Guernica* is one example of a contemporary painting in grisaille. • Cubist technique. • Points from other categories can be adapted.
Scale	• This painting is over three metres high and nearly eight metres in length. These monumental proportions immerse the viewer in this political painting. The size of the canvas gives huge visual impact to the anti-war message being portrayed by Picasso. The painting was commissioned to fit in the Spanish Pavilion at the Paris World Fair in 1937.
Mood/ atmosphere	• The monochromatic palette creates a stark mood. Exaggerated expressions created through the use of symbolic characters express the horror of war. Jagged angular lines, dark tonal background and the confusing Cubist composition communicate the chaos of the scene.
Visual impact	• See comments on scale. • Other comments can be adapted.
Success/ effectiveness	• Other comments can be adapted.
Part (b)	Social, cultural and other factors which influenced this art work
Spanish Civil War	• The Spanish town of Guernica and the surrounding area was a symbol of the Spanish Basque people who had opposed the Fascist dictator Franco. • Bombed by order of Franco, causing mass destruction. • In three hours this town was bombed and incinerated from the air by German pilots loaned to Franco from Hitler. The town was completely destroyed. • First time in modern warfare that there was no military reason to bomb a town. • The bombing raid was organised for market day and in three hours 1,850 people were killed. As people ran in terror to the fields they were machine gunned down by the German pilots. At the peak of the attack the ground temperature reached 3,000 degrees. • Horror of war communicated through the composition, visual elements and imagery in the painting.
Paris World Fair 1937	• International exhibition of manufactured products. World fairs influenced several aspects of society. • The exiled Spanish Republican government commissioned Picasso to produce a large scale mural for the Spanish Pavilion at the fair. • Picasso used this international stage to promote the horrors which had occurred at Guernica. When the fair ended, *Guernica* was sent on an international tour to create awareness of the war and raise funds for Spanish refugees. It travelled the world for nineteen years.
Politics – struggle between Fascism and Communism	• The Fascist leader Adolf Hitler was an influence on Franco who had taken over Spain in a military coup. The democratically elected Republican Spanish government was left-wing and influenced by Communism. These struggles and opposing forces are evident in the painting's composition.

The media	• Picasso read about the atrocity in the newspapers. The horrific black and white images of the destruction influenced the content of the painting. • Picasso had previously used newsprint in some of his earlier Cubist paintings.
History of art	• In the history of painting the horse has become the symbol of man's companion in war. • The woman carrying the dead child is often seen as a religious depiction of the Madonna and child as seen in the famous sculpture, *Pieta*, by Michelangelo. • *The Third of May 1808* by Goya (1814) is an anti-war painting of men facing a firing squad. It is illuminated by a single central light source similar to *Guernica*. *The Third of May* also has a strong triangular composition, similar to the arrangement created by the woman with arms held high in the burning building in Guernica. Goya's masterpiece was seen as a symbol of resistance. • The fallen soldier in Picasso's *Guernica* and in Goya's painting both have the religious symbol of Christ's stigmata on their hands. • Picasso was also inspired by Spanish artist Goya's Disasters of War series of etchings.
Bullfighting	• The bull is a national symbol of Spain and the bullfight represents a fight to the death.
Paul Cezanne	• Cezanne was the first artist to create paintings which did not attempt to be representations of nature. He distorted perspective deliberately to achieve balance and harmony. Picasso was influenced by this idea but instead distorted the perspective in *Guernica* to create a feeling of chaos and confusion.
Cubism	• Cubism is seen as the most influential modern art movement of the twentieth century. It was developed by Pablo Picasso and Georges Braque. The ideas of the movement were influenced by Cezanne and Picasso declared him the 'father of modern art'. *Guernica* is an iconic Cubist painting, rejecting traditional techniques and a singular viewpoint. Instead Picasso created a painting representing a scene from multiple viewpoints, creating a fractured composition.
Primitive art	• Picasso was influenced by primitive art, especially African masks, which have inspired the stylised mask-like faces in *Guernica*. The painting also has a primitive energy communicating Picasso's raw emotion in response to the horror of the event.
Dora Maar	• Picasso was in a relationship with the photographer Dora Maar when the painting was created. During this period his style changed as it did with every major relationship he became involved in. This time, his style became angular with hard lines and fractured geometry. This mirrored his relationship with Maar, which was tense and stormy because of her fractious and demanding personality.

Fiona's prelim response

After completing her study matrix, Fiona felt much more confident about attempting her prelim Question Paper. This was the question she selected.

> Answer this question with reference to any art work(s) you have studied.
>
> a) Discuss the artist's(s') *use of scale* and/or the *imagery* for the art work(s). **10**
>
> b) Explain the influence of *social*, *cultural* and/or *other factors* on any of the art work(s) discussed. **10**

Fiona found it helpful to structure her response using sub-headings so that she didn't stray from the question asked.

	Fiona's prelim response	Marks
(a)	An art work that I have studied is *Guernica* painted by Pablo Picasso in 1937. Picasso reacted to the chaos of war to create this Cubist work to help him to make some sense of what had happened.	
	Scale	
	This painting is over three metres high and nearly eight metres in length. Picasso was commissioned to paint this enormous mural for the Spanish Pavilion as part of the World Fair in Paris in 1937. Partly because of its huge scale, the painting became known as one of the most powerful anti-war paintings of the twentieth century. The scale of the imagery sent a powerful message to the world about the atrocities that had occurred during the bombing of the Spanish town of Guernica. The scale of the painting emphasised the horrific scene that was depicted by Picasso and gives the viewer the sense of being enveloped in the actual war scene. The monumental scale of the painting and the characters depicted give the viewer maximum visual impact.	✓ ✓ ✓
	Imagery	
	The imagery of *Guernica* is extremely powerful. Picasso painted this large scale anti-war painting in a monochromatic palette, which gives the symbolism of the imagery more strength and visual power as there is no distraction caused by colour. Picasso organised the imagery within a complex composition that can be divided into three areas. The bull, mother and child are positioned on the right-hand side of the canvas, an exploding eye, wounded horse and severed arm with sword in the centre of the painting and on the left-hand side the burning buildings and women screaming.	✓ ✓
	This imagery is seen as being part of the Cubist, Symbolist and Surrealist art movements. Picasso's strong use of symbolic imagery is seen throughout this complex painting. The image of the bull is seen as the national symbol of Spain with its culture of bull fighting. The imagery depicts many of the symbols seen in a bull-fighting ring: a man with a severed arm holding a sword could be a fallen matador. This figure is also said to symbolise the fallen republican army of Spain, while the bull is said to represent the Fascist dictator Franco, who ordered the bombing. One of the interpretations of the image of the wounded horse is that it symbolises the Spanish people fighting to the end even if they have been mortally wounded. The severed arm of the soldier is holding on to a single flower, which symbolises the fragility of life and a symbol of hope.	✓ ✓
	One of the most interesting images is the 'eye', which is positioned centrally. It can be interpreted in multiple ways. It can be seen as a light source because of the exploding light bulb shape or as a representation of the sun. It is also perceived as the eye of the artist depicting what he sees or the eye of God witnessing the horrors of war. In Spanish the word for light bulb is similar in sound to the word for bomb, so Picasso may have been influenced by this when creating this imagery.	✓ ✓
	The imagery is painted in a distinctive Cubist style with multiple viewpoints and distorted perspective, which adds to the chaos and confusion of the scene. The imagery is stylised so that the shapes are angular and fragmented. One example is the way Picasso has depicted the tongues of the horse and the screaming woman. The pointed shapes suggest the sound of the piercing screams.	✓ **10**

(b)	Influence of social, cultural and other factors on *Guernica*	
	There are many influences on this iconic work. The main influence was the historical event of the bombing of the town of Guernica during the Spanish Civil War. Many innocent civilians died when General Franco ordered the three-hour bombing raid on a busy market day. The senselessness of the event in his home country shocked Picasso, who was inspired to create this work in reaction to the horror. The horror of war is communicated through the composition, visual elements and imagery in the painting.	✓
	The monochromatic palette is a symbolic reference to the newspaper articles that Picasso read of the massacre. Newspapers were one of the main sources of communication during this period of time. This influence of the media can also be seen in the textural marks on the horse, which are reminiscent of newsprint.	✓
	There are many references to the history of art in the painting. The woman carrying the dead child is often seen as being a depiction of the Madonna and child as seen in the famous sculpture, *Pieta*, by Michelangelo. Picasso's version is in a Cubist rather than classic style but the resemblance is still clear.	✓
	The Third of May 1808, by Spanish artist Goya, is an anti-war painting of men facing a firing squad. Goya's masterpiece was seen as a symbol of resistance and there is no doubt that Picasso would have been familiar with the famous painting. It is illuminated by a single central light source similar to *Guernica*. *The Third of May* also has a strong triangular composition, similar to the arrangement created by the woman with arms held high in the burning building in *Guernica*.	✓
	Picasso was also inspired by Goya's Disasters of War series of etchings. These graphic images depicting various atrocities of war are also monochromatic studies, which may have inspired the absence of colour in *Guernica*.	✓
	The Cubist style evident in *Guernica* was influenced by the work of the Post-Impressionist artist Cezanne. He is regarded as the first artist to create paintings which did not attempt to be representations of nature. He distorted perspective deliberately to achieve balance and harmony. Picasso was influenced by this idea but instead distorted the perspective in *Guernica* to create a feeling of chaos and confusion.	✓
	Cubism is seen as the most influential modern art movement of the twentieth century. It was developed by Pablo Picasso and Georges Braque. The ideas of the movement were influenced by Cezanne and Picasso declared him the 'father of modern art'. *Guernica* is an iconic Cubist painting, rejecting traditional techniques and a singular viewpoint. Instead Picasso created a painting representing a scene from multiple viewpoints creating a fractured composition and a feeling of disorientation which helps to convey the terrible mood of the event. In *Guernica*, the fractured and multiple viewpoints create a central triangular composition which uses complex and overlapping imagery, emphasising the multifaceted perspective of war.	✓ ✓
	At the time of painting *Guernica*, Picasso was in a relationship with the photographer Dora Maar. During this period his style changed as it did with every major relationship he encountered. This time, his style became angular with hard lines and fractured geometry. This reflected his relationship with Maar, which was tense and stormy. This sharp and jagged style which is apparent in Guernica can also be seen in other paintings of this period, such as *Weeping Woman*.	✓
	Primitive art was a key influence on Cubism, and this can be seen in *Guernica* in the depiction of the faces, which are suggestive of tribal masks. The simplified profile faces of the screaming figures clearly show this influence. This primitive symbolism conveys raw energy which helps to convey the emotion of the event and Picasso's personal reaction to it.	✓ ✓ **10**
		Total: 20

Teacher's feedback

Fiona, this is an excellent response, particularly under exam conditions. You have clearly prepared well. The study matrix which you created seems to have helped you to organise your thoughts in the exam.

The use of sub-headings has worked well for you and you have demonstrated that you know how to write well-justified and well-explained comments.

Part (b) is well structured. You have related all of your points to the painting and you have avoided falling into the trap of including any irrelevant information.

An impressive performance!

Section 2: Design studies

There are many elements relating to Design you may be asked to comment on. These might include:

Function or Fitness for purpose	• purpose; primary and secondary functions; effectiveness; durability; practicality/wearability; safety; ergonomics/user-friendliness
Aesthetics/ Style	• visual impact; visual elements – line, tone, colour, shape, form, texture, pattern – how visual elements have been used/combined; influences of other designers/design movements; sources of inspiration; scale; detail; decoration
Visual elements	• use of line, tone, colour, shape, pattern, texture, form
Materials/ Techniques	• choice of materials; processes used; use of technology; production/construction methods; skills demonstrated; effect on the function and appearance of the design; suitability; cost
Target market/ Audience	• the market/audience the design is aimed at; consumer type; client; age group; gender; income bracket; interests; preferences; personality type
Visual impact	• effectiveness of the visual impact and how this has been achieved; how effectively the design appeals visually
Effectiveness/ Success of the design	• your opinion on the effectiveness/success, with reasons relating to the fitness for purpose, aesthetics, visual impact, appeal to target market, your own preferences

COMMON MISTAKES

Sometimes students answer questions in a narrow way and run out of points to make. They don't realise that many design elements are related to many others. For example, aesthetics may impact on a design's fitness for purpose, or its appeal to a target market. You can develop your answers by relating the elements asked about to other design issues, so long as you always stay focused on the question.

Questions 5 and 6: Design studies image question

You will choose **one question** to answer from this selection. This part of the paper is all about responding to an unseen image which may, or may not, be from a design area with which you are familiar. You will be applying what you have learned to the analysis of a particular design work. The marker will expect to see that you have a knowledge and understanding of design practice and that you are able to apply terminology correctly and effectively.

Each question in this section has a related image. These will change from year to year, but you can get an idea of the variety likely to come up by looking at SQA's Specimen and Exemplar Question Papers and past papers on their website. You can also prepare for this part of the paper by trying to broaden your knowledge of design in general, particularly learning the terminology related to less familiar areas.

Once you have read through this section, along with the worked examples, try to answer questions from past papers, including those which do not relate to the topic you are studying in class. There are no 'right answers' but your responses should focus directly on the question asked and should show a good knowledge and understanding of design practice.

HINTS & TIPS

These questions will only involve two design areas. An area that you have a lot of knowledge of may come up. You may also be able to used transferable knowledge from other subjects, such as Design & Manufacture or Graphic Communications. However, you may be asked about design areas of which you have little experience. You must prepare for this eventuality. Remember that all design areas have some issues and terminology in common.

You may expect to find images from **two** of the folllowing areas:

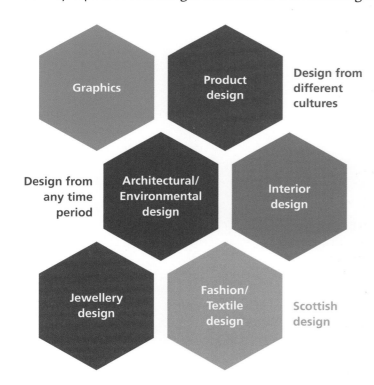

Graphics

Product design

Design from different cultures

Design from any time period

Architectural/ Environmental design

Interior design

Jewellery design

Fashion/ Textile design

Scottish design

Questions 5 and 6: Structure

These questions are divided into two parts – part (a) and part (b). Part (a) is fairly straightforward. Part (b) is meant to be challenging. The structure can be illustrated as follows:

(a)

Describe the use of design *prompt* (a) 1

Describe the use of design *prompt* (a) 2

(b)

Design *prompt* (a) 1 **+** Design *prompt* (a) 2 **=** Explain effect on *prompt* (b) 3

Questions 5 and 6: Design studies image case studies

Amryt's response

Life – Just Add Water poster design (2011)
by Shepard Fairey
hand screen-printed

With reference to this image:

a) describe the designer's use of *imagery* and *lettering* in this work **6**
b) explain how the designer's combined use of *imagery* and *lettering* would appeal to a *target audience*. **4**

Amryt's teacher gave this question, based on a graphic design, as a homework task. It was the first time she had attempted this kind of question. Her response was as follows:

	Amryt's response	Marks
(a)	The imagery has a limited colour palette of red and blue which are contrasting hot and cold colours. This gives the poster visual impact. There is a stylised tap and an image of a child contained inside a water droplet which is a teardrop shape. The child drinking water contained inside the droplet is depicted in a simplified tonal range which makes it stylised and easy to understand. This is a striking image which helps communicate what the event is for – to raise money to provide water wells in Africa.	✓
	The idea of water is further reinforced by the predominantly blue imagery as blue is a colour we associate with water. The symbol of a tap which is used to form the letter T in the word 'water' is a clever idea which makes it very clear that the poster is about water, even if you have not read the information.	✓ ✓
	The vinyl record in the background is effective use of imagery as it suggests a musical aspect to the event. This simplified retro style imagery makes the poster look older than it is.	✓ ✓
	The lettering is mostly a simple sans serif style which communicates the information clearly. The lettering is arranged in horizontal bands in different sizes and styles of fonts. This adds variety and emphasises the information. 'Water' is the largest word which attracts the viewer – who can then look closely to read the other information. 'Benefit Concert' is written in typography which looks like old typewriter lettering. This adds to the retro style of the poster. Most of the lettering is white or a light colour which contrasts with the background and draws the viewer's attention to the highlighted information.	✓ ✓ ✓ 6
(b)	I think this poster would appeal to a slightly older audience as it has a 1960s retro style. The audience would be music lovers as the event is a concert. The audience would also be people who are likely to give to charity as it is a benefit concert to raise money for water wells in Africa. The contrasting colours create visual impact, attracting the relevant target audience.	0 Total: 6

Teacher's feedback

Amryt, you have answered part (a) very well and gained full marks for this aspect. You have made quite a few points relating to colour but have gained marks as you remembered to relate these to the question prompt about imagery. However, in part (b) you have not answered the question asked. Although you have made valid points, you have not linked your comments on target audience to the imagery or lettering. This means that no marks can be given for this section.

I will go over this in class and then I would like you to redraft part (b).

After getting feedback on her homework and listening to her teacher's explanation about how to answer part (b), Amryt made a grid to help her to make another attempt at part (b). She took the original comments from her previous response, but this time, she used the (a) 1 + (a) 2 = (b) formula to ensure that she answered part (b) effectively.

Part (a) 1 Imagery	Part (a) 2 Lettering	(a) 1 + (a) 2 = (b) Combined effect on a target audience
Simplified imagery has a limited colour palette – red and blue – contrast through hot and cold colours	Mostly simple sans serif lettering – clear communication.	Strong simplified symbols – clear communication Contrasting colours creates visual impact attracting the relevant target audience
Stylised tap and water droplet – teardrop shape	Placement of lettering	Simplified – reduced visual information Stylised Easy to understand
Child drinking water – simplified tonal range – main images in shades of blue – colour of imagery emphasises idea of water	Different sizes and styles of fonts. Adds variety and emphasises the information	People who give to charity Charity aspect is very clear from the visual and the lettering 'Water' is the largest word – then the viewer can look closely to read the other information
Use of symbolism – vinyl record reinforces the idea of music	Most of the lettering is white or a light colour which contrasts with the background	Music lovers Message conveyed using symbols and visual imagery Effectively promoting music for a charity event in a visual way
Retro style imagery – makes the poster look older than it is	Retro style lettering – 'Benefit Concert' looks like old typewriter lettering	Retro style appeals to older target audience with disposable income

	Amryt's reworked part (b) response	Marks
(b)	I think this poster would appeal to a slightly older audience as it has a retro style because of the retro style lettering combined with the stylised imagery, which reminds me of 1960s Pop Art images. The image of the vinyl record together with the lettering which communicates that the poster is advertising a concert means that it would appeal to music lovers. The stylised imagery of the child inside the water droplet and the tap symbol juxtaposed with the simple text which clearly communicates the fact that it is a charity event means that the design would appeal to people who are likely to give to charity; it is obvious that it is for a benefit concert to raise money for water wells in Africa. The imagery shown using contrasting warm and cold colours in conjunction with the lighter typography helps create visual impact, attracting the relevant target audience: an older audience of music lovers who have enough disposable income to donate to charity.	✓ ✓ ✓ ✓ 4

Teacher's feedback

Much better, Amryt. You seem to have got the idea of how to answer part (b). Well done!

Jacob's response

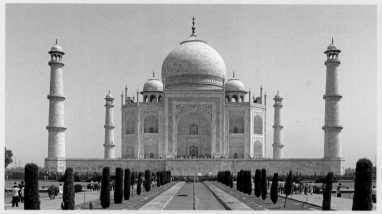

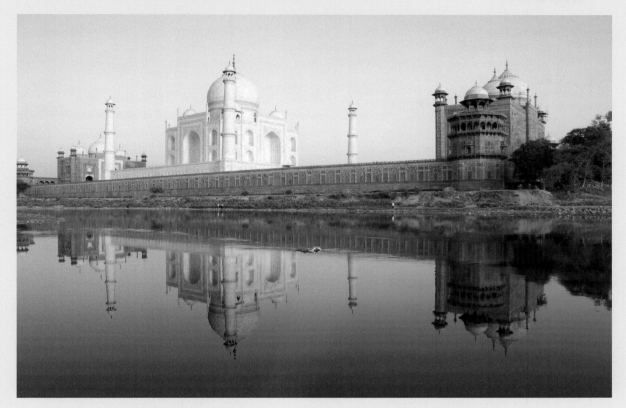

Taj Mahal Mausoleum[1] (1632) India designed by Ustad Ahmad Lahauri
materials: white marble, red brick and ceramic tiles
([1]mausoleum – a building which contains a tomb)

With reference to this image:

a) describe the designer's use of *form* and *decoration* in this work **6**

b) explain how the designer's combined use of *form* and *decoration* contribute to the *visual impact* of this building. **4**

Before writing his response Jacob found it useful to take a few moments
to write some lists of key words relating to the question. Jacob had not
studied architecture as part of his Unit, but realised that the choice of
design questions is limited. He had been learning terminology from
different design areas in class and for homework so that he was able to
answer questions on less familiar topics.

(a) 1 Form	(a) 2 Decoration	(b) Visual impact
vertical horizontal	geometric tessellation	monumental scale
geometric symmetrical	ornate symmetry	oriental eastern style attention to detail
domes flowers and vines	frames flowers and vines	white – purity contrast – red brickwork
rectilinear curvilinear	arched windows	repeating elements

	Jacob's response	Marks
(a)	The architect has designed a symmetrical structural form which results in the central domed building becoming the focal point. The domed building is surrounded on four corners by tall towers. These repeating vertical linear forms contrast with domed forms and lead the eye into the centre of the building and emphasise the geometrical perspective. The rectilinear and curvilinear forms contrast with each other. The tall vertical forms contrast visually with the low horizontal forms. The building, which looks pure white from a distance, actually contains a lot of decoration. This is achieved in a number of ways. The designer has used decorative tiles with a variety of different patterns of flowers, vines and calligraphic pattern which shows attention to detail. The brickwork and marble blocks used to construct the building are also decorative and achieve pattern through tessellation. Even the windows have a decorative purpose with their ornate arched design and 'frames within frames' effect. The geometric framework is an important aspect of the decoration throughout the building.	✓ ✓ ✓ ✓ ✓ ✓ 6
(b)	The design of the building using geometric forms combined with decorative organic pattern creates a sense of organisation, which creates a complex style. This gives the building visual impact through the initial impression and then the further attention to detail in the decoration which captivates the visitor. The onion-domed traditional structural form in conjunction with the applied tiled decoration creates a sense of eastern style, which contributes to the visual impact. The repeated vertical cylindrical forms of the towers with their decorative domed turrets give the building symmetry and a sense of unity, adding to the visual impact. Visual impact is further enhanced by the decorative geometric 'frames within frames' incorporated with the position of the forms of the towers which create an illusion of perspective. The monumental scale of the form together with the pale colour of the decoration creates visual impact as the building can be seen from afar and leads the visitor to believe that this must be a very important mausoleum created for a very important person's tomb.	✓ ✓ ✓ ✓ ✓ 4 Total: 10

Lauren's response

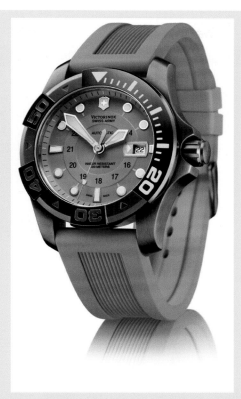

Victorinox diver's watch (2015) by an
unknown designer
materials: stainless steel and rubber
waterproof to a depth of 500 metres

With reference to this image:

a) describe the designer's use of *style* and consideration of *function* in this work **6**
b) explain how the designer's combined use of *style* and consideration of *function* would
 appeal to a *target market*. **4**

Question (a) 1 Style	Question (a) 2 Function	(a) 1 + (a) 2 = (b) Combined effect on target market appeal
Orange/grey colour scheme	High visibility	Functional high visibility colour scheme would appeal to divers as the watch can be seen in deep water
Rubber strap Decorative ridged effect	Tough Hardwearing/durable Waterproof under pressure	Orange rubber strap is stylish Functional as it would be comfortable and the watch is waterproof – mixes practicality with style
Chunky masculine style	Stainless steel will not rust	Appeal to men who like to do water sports as the material will not rust Appeal to young men who want to look 'sporty'
Simple style of numbers and symbols	Luminous hands and dots for time Size would help visibility – easy to read	Multi-functional aspect combined with simplicity – appeal to divers and sporty, fashion-conscious people

Lauren found using sub-headings helped her to stay focused on the question. As she was practising exam technique, she underlined the key words from the question. Lauren also used a thesaurus to help her to extend her vocabulary and answer these questions more effectively.

	Lauren's response	Marks
(a)	**Style** The colour of this watch strap and face is a vibrant orange which contrasts with the dark grey stainless steel and which gives it a distinctive <u>sporty style</u>. The appearance is chunky and the watch looks oversized which makes it noticeable and gives the <u>style</u> visual impact. The <u>simple style</u> of numbers and symbols on the face contributes to the <u>modern</u>, <u>streamlined sporty appearance</u>.	✓ ✓
	Consideration of function The <u>function</u> of this watch is for the sport of diving. It is <u>suitable for this sport</u> as it is waterproof and <u>made of appropriate materials</u>, such as rubber which is naturally water resistant, and stainless steel which will not rust when exposed to water. The face of the watch is a high visibility orange which would make it <u>easier to see</u> in the dark environment of the sea which would make it <u>functional</u> for diving. The numbers on the dial face are represented with dots which are <u>clear and easy to read</u>, meaning that it fulfils its primary <u>function</u> – to tell the time.	✓ ✓ ✓
	The designer has <u>considered function</u> in the design of the large button on the right-hand side of the watch face which is chunky and protruding, allowing a diver who is wearing gloves to easily adjust the knob.	✓ **6**
(b)	<u>**Combined effect of style and function on the target market appeal**</u> This bright orange rubber strap is <u>stylish</u> and trendsetting but is also <u>functional</u> as it is waterproof and comfortable. This should appeal to the <u>target market</u> of divers where a waterproof watch is essential.	✓
	The high visibility colour means that the watch is easy to see, giving it extra <u>functionality</u>. This, combined with the <u>chunky, sporty appearance</u> might appeal to a <u>target market</u> of water sport enthusiasts who are looking for a <u>stylish and practical</u> waterproof watch.	✓
	The stainless steel is <u>durable and functional</u> and together with the orange face, it creates a <u>sporty style</u>. This <u>stylish and contemporary multi-functional</u> diving watch would therefore appeal to the wider target market of fashion-conscious younger men in general. Its <u>chunky, masculine style</u> in conjunction with its <u>practical and functional aspects</u> would appeal to a <u>male target audience</u> who do not participate in sports but might buy this watch as a <u>style statement</u> or status symbol.	✓ ✓ **4** **Total: 10**

Ryan's response

Ryan was given this example to try for homework.

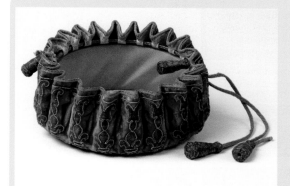

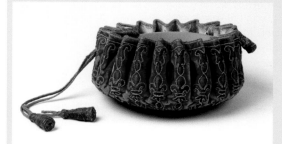

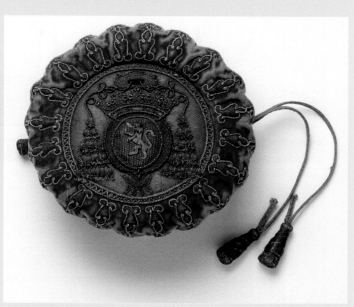

Purse (1660–1680) by an unknown designer
materials: leather, silk, silver threads, silver-gilt thread
hand sewn and hand embroidered

With reference to the image above:

a) describe the designer's use of *materials* and consideration of *style* in this work **6**
b) explain how the designer's combined use of *materials* and consideration of *style* contributes to the *fitness for purpose*. **4**

	Ryan's response	Marks
(a)	The designer has considered materials. The materials used to make this purse are leather, silk, silver thread and it is hand embroidered. The style is old-fashioned and it has a pattern on it. It is a brown and orange colour scheme. There is a decoration on the bottom which looks like a badge of some kind. It has pleats and a drawstring.	
(b)	The purse does not look very fit for purpose. It looks as if the money could fall out easily. I do not think this is a very good example of a purse.	

Teacher's feedback

Ryan, most students find these questions very challenging until they get more practice. Part (a) is very descriptive. You must try to explain and extend your responses.

In part (b), you must connect the points made to the part (a) issues of materials and style. Redraft your response. Try making some notes first, using the (a) 1 + (a) 2 = (b) formula. Most students find this helps until it becomes automatic.

(a) 1 Use of materials
Leather/properties
Ornate fabric pattern Embroidered/handmade
Silver thread/two thread drawstring
Silk/luxurious expensive
Silver gilt, toggles – decorative but expensive, weight

(a) 2 Style
Concertina drawstring
Old-fashioned
Decorative, ornate, patterned, historical

(b) Fitness for purpose
Contain a number of objects
Handcrafted, wealthy target market; unisex displaying wealth
Two drawstrings for security and attach to belt or clothing
Flat bottom/table or surface

	Ryan's redrafted response	Marks
(a)	The designer has considered materials. The materials used to make this purse are leather, silk and silver thread and it is hand embroidered. Leather is a tough material which is hard wearing but also flexible enough to fold into pleats, making it suitable for this purse design. Silk and silver thread have been used to add decorative effects. This was done by hand and would have been time-consuming and required a lot of skilled craftsmanship. The style is old-fashioned and it has an organic repeating pattern on it which makes the style ornate and decorative. It is a brown and orange colour scheme with metallic accents which remind me of royalty. This warm colour scheme makes it look expensive and it was probably a luxury item at the time. There is a decoration on the bottom which looks like a badge or insignia of some kind. This suggests it has been hand embroidered with a personal symbol so it has probably been specially made for one person. This suggests that a particular client may have chosen the style, fabric and colour scheme. The design is an unusual style for a purse nowadays, but may have been more common in the 1600s as the designer would not have had access to modern fastenings, such as zips. Therefore, a drawstring may have been the usual way to secure a purse in those days.	✓ ✓ ✓ ✓ ✓ ✓ **6**
(b)	In some ways the purse does not look very fit for purpose. The style of the pleated design along with the use of a drawstring might mean it could come loose and the contents fall out if not tied securely. For this reason, I do not think this is a very good example of a purse. However, the purse does have some good points. It most likely had a purpose as a status symbol and the owner would have used it to show how wealthy they were. This would have been achieved through the decorative style, including the heavily embroidered insignia combined with the use of expensive materials. The materials would have been hard wearing, particularly the leather, which would mean it would be durable and last a long time. The style of the purse means that it could also have been placed on a table because of its flat bottom. The way the soft, durable materials fold in make it stable when closed which would make it more fit for purpose. The purse could also be used to contain money and small precious objects. The pleated style would allow it to expand easily and in combination with the soft materials this would mean that it could accommodate a variety of different objects and still be closed. If then tied securely, it would be fit for its main purpose.	✓ ✓ ✓ ✓ **4** **Total: 10**

Teacher's feedback

You have really managed to turn this around in your redraft. Hopefully you will now see that it is not too difficult once you understand what is expected.

You have structured part (a) well and remembered to explain all your points in detail.

Part (b) is much improved and you have remembered to use the key question prompts in your response which makes it much easier for the examiner to award you marks.

Your next challenge is to practise these types of questions against the clock as you do not have much time to structure your response in the exam and you really will have to 'think on your feet'.

Well done and keep up this effort!

Questions 7 and 8: Design studies essay question

You will choose **one question** to answer from this selection. This part of the paper is all about demonstrating knowledge and understanding of Design practice through discussion of works you have previously studied. You will be expected to show that you can apply your knowledge and understanding in response to an unseen question.

Questions are structured so that a number of different approaches can be taken. This is to reflect the variety of topics and methods which schools use in teaching Design studies. For example, you could respond to a question by discussing one design, or many designs. You may focus on the work of one designer, two designers or several designers.

Questions change from year to year, so you cannot predict which design issues you will be asked to comment on. However, one element of the question remains unchanged: you will **always** be asked to comment on the social, cultural and/or other influences on the design(s) you have selected.

To help you understand the format, read through this section, along with the worked examples.

Questions 7 and 8: Structure

These questions are divided into two parts – part (a) and part (b). Part (a) will change from year to year. Part (b) will remain unchanged, so you should find that you can prepare for this part of the question. The structure can be illustrated as follows:

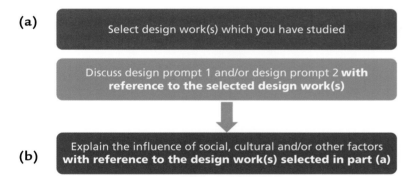

(a)

> Select design work(s) which you have studied

> Discuss design prompt 1 and/or design prompt 2 **with reference to the selected design work(s)**

(b)

> Explain the influence of social, cultural and/or other factors **with reference to the design work(s) selected in part (a)**

HINTS & TIPS

You must discuss the same design work(s) in part (a) and part (b).

In part (b) ensure that you discuss social, cultural and/or other influences by referring to their impact on the selected design work(s) rather than discussing the influences in general.

COMMON MISTAKES

Many students think that studying involves reading their notes over and over. This has been shown to be a very ineffective way to study. 'Active' methods are much more effective. This means working with the materials, testing yourself and attempting exam-style questions.

Questions 7 and 8: Design studies essay question examples

Daniel's response

In preparation for their prelim exam, Daniel's class were given this practice question for homework. This was his first attempt.

> Answer this question with reference to any design work(s) you have studied.
> a) Discuss the designer's(s') *use of materials/techniques* and/or the *consideration of style* for the design work(s). **10**
> b) Explain the influence of *social, cultural* and/or *other factors* on any of the design work(s) discussed. **10**

	Daniel's first attempt for part (a)	Marks
(a)	I will discuss the Dragonfly corsage brooch by René Lalique and the Art Deco jabot pin by Georges Fouquet.	
	The materials used to make the Dragonfly brooch are gold, enamel, chrysophase, moonstones and diamonds. These are precious and semi-precious materials. It was made especially for the actress Sarah Bernhardt. It is 23 cm long and over 26 cm wide.	
	Fouquet has used gold, platinum, diamonds, onyx and coral. This is also a mix of precious and semi-precious materials.	
	The Lalique brooch is made with a lot of attention to detail. The colours are the same as a real dragonfly. The Fouquet jabot pin is simpler. It is made of shapes.	
	The style of the Lalique brooch is Art Nouveau. This style was very popular. The brooch looks like a woman combined with a dragonfly. It also has sharp claws like a bird.	
	The Fouquet pin is an Art Deco style. It is black and red. The Art Deco style was popular in the 1920s and 1930s.	**0**

Teacher's feedback

Daniel, everything you have said in part (a) is correct. However, your response is descriptive and you are not developing your comments. Simply regurgitating memorised statements such as 'These are precious and semi-precious materials' is a risky approach. A lenient examiner might possibly award one or even two marks, but to gain higher marks, you need to give more detail and explanation. You also need to make it very clear that you understand the techniques used and the effect of these – try to relate them to other design issues, such as function. Use the question prompt words frequently in your answer. When discussing Fouquet's work, try to relate it to the Art Deco style. Remember what you have learned in class and try to extend your descriptive vocabulary..

	Daniel's first attempt for part (b)	Marks
(b)	Lalique's Dragonfly corsage brooch was made in 1897 and is from the Art Nouveau period. Art Nouveau designers were inspired by nature, especially plants. The style was famous for its 'whiplash line'. It was an international movement which swept Europe and America.	
	Another influence on Art Nouveau was Japanese art.	
	The Paris Universal Exhibition in 1900 featured a lot of Art Nouveau design.	
	Fouquet's bracelet is from the Art Deco period and was designed in 1925. Art Deco was an international design movement which occurred between the two world wars.	
	The influence from the Far East and Africa were a major factor in the development of Art Deco movement.	
	The Art Deco style is known to have been influenced by the discovery of Tutankhamun's tomb.	
	The Russian ballet was another key influence on the Art Deco style.	
	Various movements in art such as Russian Constructivism and Cubism influenced Art Deco.	0

Teacher's feedback

You have made two major mistakes in part (b), Daniel. The question clearly asks you to comment on any of the design work(s) already discussed in part (a). You have introduced a new design by Fouquet, so these comments cannot be awarded marks. You have then discussed influences on Lalique and the design movements in general, rather than the impact of the influences on the work. It may seem harsh to gain no marks, as you are demonstrating knowledge and understanding, but this is how your response would be marked in the final exam. Again, a generous examiner might possibly award one mark for the reference to nature being an influence on Art Nouveau but that's about all.

I recommend that you redraft your response so that you are discussing exactly the same works in part (a) and part (b). Make sure you comment on the work, rather than making general statements about design movements.

	Daniel's redrafted attempt	Marks
(a)	I will discuss the Dragonfly corsage brooch by René Lalique and the Art Deco jabot pin by Georges Fouquet.	
	The materials used to make the Dragonfly brooch are gold, enamel, chrysophase, moonstones and diamonds. These are precious and semi-precious materials and this combination was unusual for the time. Lalique was one of the first designers to use this combination of materials. The brooch is made using traditional jewellery-making techniques. Lalique modelled the gold sections in wax and then used the 'lost-wax' technique to cast these pieces, allowing him to capture the intricate detail of the bird's claws.	✓ ✓
	The body is articulated to make it flexible and the wings are hinged using tiny hinges. This would have required a great deal of skill and means that the brooch is more comfortable for the wearer as it is less rigid than it looks and can move with the body. Plique-à-jour enamelling is a technique that involves using molten glass to add colour to specific areas. Lalique used this technique to add the iridescent blues reminiscent of dragonflies and peacocks to the brooch.	✓ ✓
	The brooch was made especially for the famous actress Sarah Bernhardt. The style was intended to create visual impact as she had a larger-than-life personality and extravagant style and was considered a fashion icon. Lalique achieved a dramatic style partly through the large scale of the piece (23 cm long and over 26 cm wide) and partly through the unusual combination of natural forms. The brooch looks like a woman combined with a dragonfly. It also has sharp claws like a bird. The style of the brooch is Art Nouveau and it is very typical of this movement with its sources of inspiration based on nature combined with the female form, particularly the idealised female form.	✓ ✓ ✓

Fouquet has used gold, platinum, diamonds, onyx and coral. This is also a mix of precious and semi-precious metals and stones which was becoming a more common choice of materials for jewellery designers during the Art Deco period. Traditional jewellery-making techniques are also used for this piece, but they would not require the complexity of the Lalique piece. The onyx and coral pieces have been polished into a cabochon form and rose-cut diamonds have been used to add a touch of glamour. ✓ ✓

The Fouquet jabot pin is simpler in style but is also striking. The Fouquet pin is typical of the Art Deco style which was popular in the 1920s and 1930s. It is a vivid and stylish black and red colour combination. It is constructed from geometric shapes and forms, specifically circles and semi-spheres. It would have been considered futuristic and avant-garde in its day. ✓

10

(b) Lalique's Dragonfly corsage brooch was made in 1897 and is from the Art Nouveau period. Art Nouveau designers, as a direct influence of the Arts & Crafts movement which occurred in the late 1800s, were inspired by nature. This influence is evident in the brooch with its clear references to dragonflies and birds. The wings are decorated in a pattern which looks like peacock feathers. Art Nouveau was an international movement which swept across Europe and America. This is a very common Art Nouveau motif and can be seen in many other designs for jewellery, textiles and graphics and was very fashionable at the time. ✓ ✓

Another key influence on Art Nouveau was Japanese art. 'Japonisme' was all the rage in Europe and fashionable people collected Japanese art and objects. This influence can be seen in the Dragonfly corsage mainly through the use of enamelling which was a technique imported from the Far East. Japanese artists were also very inspired by nature and the Japanese style is apparent in Lalique's piece, which although large in scale, retains a delicate appearance. ✓ ✓

Mythology is also a cultural influence on this brooch, as Lalique has created a hybrid creature, part woman, part insect, part bird, which reminds me of the griffin and harpies of Greek and Roman myths. ✓

Fouquet's jabot pin is from the Art Deco period and was designed in 1920. Art Deco was an international design movement which occurred between the two world wars. At this time there was a fascination with speed, travel and modernity. The circles used in the pin are reminiscent of the cogs of a machine and are clearly a reference to the machine age which is an influence of the Art Deco style. ✓

The influence from the Far East and Africa are an apparent influence on the materials used in the pin and brooch. These exotic materials would have been imported from abroad. The availability of these materials was possible because of the colonisation of countries in Africa and the Far East and more accessible transportation. ✓

The Russian ballet was another key influence on the Art Deco style, which is reflected in the style of Fouquet's pin. The sets and costumes had a major influence on this new movement. The costumes designed by Léon Bakst and Natalia Goncharova often featured geometric patterns and vivid colour combinations such as red and black. The geometric motifs used in the jewellery are symbolic of this avant-garde influence. ✓

Movements in expressive art were another cultural influence on this piece. Russian constructivism involved very minimalistic, geometric compositions which created a dynamic, abstract effect. This pin has a similar style and painters from this movement often used a predominantly red and black colour palette, which may have influenced the design of this pin. The distinctive geometric shapes and forms of Cubism, which was becoming more widely known in this period, could also have been an influence on this piece. ✓ ✓

10
Total: 20

Teacher's feedback

A great response, Daniel! You have clearly been paying attention to how to deal with these questions. Keep practising different versions of these questions so that you are well prepared for anything that comes up in the prelim and the final exam.

Questions 7 and 8: Design studies essay question: Adam's study technique

In order to prepare for Questions 7 and 8 in his final exam, Adam decided to focus on the Red House, which he had chosen to study in his Architecture Design Unit. He had also learned about the work of a contemporary architect, but he felt that the Red House would give him plenty of material to write about in the exam. This also cut down on his workload and allowed him to focus on this one design when he was studying.

To prepare for part (a) Adam researched SQA past papers, including Specimen and Exemplar Question Papers on their website. Although he discovered that this part of the question is unpredictable, the past papers gave him an idea of issues he might be asked about.

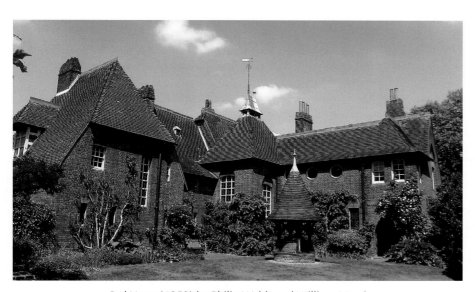

Red House (1859) by Philip Webb and William Morris

Adam's study matrix

Study matrix: The Red House by Philip Webb and William Morris, 1859	
Part (a)	Design issues
Aesthetics/ Style/Sources of inspiration	The house has minimal applied ornamentation; most of its decorative features had constructional purposes, such as the arches over the windows. This was a radical idea at the time, as most contemporary Victorian buildings were heavily ornamented.
	The steep roofs, prominent chimneys, cross gables and exposed ceiling beams give it a particular neo-Gothic aesthetic.
	The L-shape plan creates asymmetry typical of traditional Gothic buildings that would have been added to over time.
	The house derives its name from the use of local red brick and red roof tiles, which give it a distinctive appearance and its dominant red colour.
	There is a variety of different window types present, which add to the individuality of the building's appearance. These include tall casements, hipped dormers, round-topped sash-windows and round windows. Stained glass windows were also installed in the house, with medieval-inspired designs created by Burne-Jones and Webb. These flood the interior with coloured light and add to the neo-Gothic ambience.
	Morris chose to design and create almost everything for the interior by himself. Only a few ready-made items were purchased, such as Persian carpets and oriental blue china. Some other items of furniture were specially designed by Webb, including the oak dining table, other tables, chairs, cupboards, copper candlesticks and glass tableware. All of the items were inspired by nature and were executed in a neo-Gothic style. This unified the style of the interior and reflected the beauty of nature and the medieval guild ideal.

Target market/ Audience	Constructed as a family home for Morris and his wife.
	Morris also had the idea that it could be used as a meeting place for like-minded artists and designers, and gatherings were often held in the house with several prominent artists, writers and thinkers attending. The artist Burne-Jones said it was 'the beautifullest place on Earth'.
	The house was a private residence until 2003, when it was acquired by the National Trust. It is now a tourist attraction and has many visitors each year.
Function/ Fitness for purpose/ Effectiveness	Morris insisted on integration of the design of the house and garden. As a result, the Red House has an L-shaped plan. The L-shaped plan incorporated the gardens as a part of the domestic living space, which is not a new idea today, but which was unusual then.
	The house is spacious inside; it has two floors. On the first floor were situated the main living-rooms, which was unusual.
	The high-pitched roof made of red tiles is functional in making the house weatherproof and in letting the rain drain away quickly.
	Unlike the typical Victorian architecture of the day, the windows were positioned to suit the design of the rooms instead of conforming to an external pattern; the variety of different window types allow light to enter rooms where it is needed.
	Morris and Webb collaborated so that the architecture and interior design were a unified whole. He felt that this would encourage domestic harmony and foster creativity in all those who stayed at the house.
	Ironically, after five years Morris moved out as he found that the house was too expensive to run and did not suit his lifestyle as much as he thought it would.
	The house is north-facing, meaning the interior of the house was cold in the winter. Its isolated location became an issue as it was a three-mile journey by carriage from the house to the nearest railway station. It took Morris up to four hours a day to get to his offices, which was impractical.
Materials/ Techniques	Morris tried to return completely to medieval Gothic methods of craftsmanship. He tried to reinstate craft as one of the fine arts. Although he aimed for affordability and anti-elitism, this could not be sustained as hand-crafting techniques were time-consuming and expensive.
	Local and vernacular materials were used, such as red brick, red roof tiles and English oak. This gave the house its distinctive appearance and was sustainable in an age when that was a concept which was unfamiliar.
	Use of exposed red brick for the exterior gave the house its name and revealed the innate natural beauty of the construction materials. Morris and Webb valued the properties of natural materials, which they thought were far superior to and healthier than industrially produced materials.
Key visual elements	Form; Colour
Visual impact	The house integrated with its surroundings to an extent, but could also be seen from a distance.
	Its decoration, although simplified and minimal, was striking and had visual impact.
Part (b)	Social, cultural and other factors which influenced this design
Art and Crafts Movement	It was constructed using Morris's ethos on craftsmanship and artisan skills, thus reflecting an early example of what came to be known as the Arts and Crafts Movement.
University studies at Oxford University's Exeter College, focusing on Classics	There, he developed a keen interest in medieval history and medieval architecture, inspired by Oxford's many medieval buildings.
	Morris had inscribed a Latin motto, 'Ars longa, vita brevis', meaning 'Life is short, but art endures'. The decoration over the front door was the Latin inscription, 'Dominus Custodiat Exitum Tuum et Introitum Tuum' – 'God preserve your going out and your coming in'.
	The walls of the staircase were intended to feature a painted mural by Burne-Jones depicting scenes from the Trojan War.
Medievalism and medieval-inspired neo-Gothic style	Reflected throughout the building's design – give examples.
	The passage which connects the main hallway to the house's rear entrance was called The Pilgrim's Rest as a reference to the route taken by medieval pilgrims travelling to Canterbury.

Great Exhibition of 1851	Rejection of Victorian values and the products and processes of the Industrial Revolution.
	Britain's growing Medievalist movement rejected the values of Victorian industrial capitalism. Morris was concerned by the effects that the Industrial Revolution was having on the environment, society and workers employed in factories. In the Red House, none of the furniture was made in factories, but was hand-crafted instead.
	Morris wanted to create a pre-capitalist sense of community in the house and succeeded in doing so when it became a hub for artists and writers to meet. All who visited admired the style of the house and the honesty with which it had been constructed.
Writings of art critic John Ruskin, particularly 'On the Nature of Gothic Architecture'	Morris was inspired by Ruskin's philosophy of rejecting the poor quality industrial manufacture of decorative arts and architecture and return to hand-craftsmanship instead. John Ruskin believed that the inexpensive, factory-made goods flooding the markets had a negative effect on both those who made them and those who bought them. In commissioning all of the furniture and decoration in the Red House to be hand-crafted, he felt that he could raise artisans to the status of artists. He also believed that he could create art that would be affordable and handmade. He never quite achieved this as the furniture was expensive to manufacture.
The Pre-Raphaelite painters	Edward Burne-Jones and Dante Gabriel Rossetti, both of whom aided him in decorating the House; various Burne-Jones wall murals remain.
Gothic revival architect George Edmund Street	Worked for this Oxford-based architect in 1856.
	Influence on the style of his work as he was later to develop the neo-Gothic style in the design of the Red House.
	He also worked there with Philip Webb, with whom he collaborated on the Red House.
Arthurianism and the Age of Chivalry	Art based on the legends of King Arthur – murals and decoration in the interior of the Red House reflect this interest. A mural by Burne-Jones depicts the marriage feast of Sir Degrevant – a knight of the Round Table.
Vernacular architecture	Morris and Webb were influenced by traditional vernacular styles of architecture, so the building's appearance reflects the style of cottages that would have been built in that area previously.
Socialism and Social Reform	The servants' quarters were larger than in most contemporary buildings, reflecting the new ideas on working-class conditions which would lead Morris and Webb to become socialists in later life.
	Ruskin and his followers promoted the medieval guild model in which artisans were responsible for hand-crafting their works from beginning to end as opposed to items being made on a factory production line. They believed this produced a sense of pride in the worker and guaranteed quality products for the consumer. All of the furniture and decoration in the Red House was made according to this principle.
Cult of domesticity	This Victorian idea saw the home as a sanctuary from the negative influences of city life. The Red House was such a sanctuary for Morris and the frequent visitors who went there.
Sustainability	The house was built so that few trees needed to be cut down. Morris was interested in ecology, even in those early times.
	The materials were sourced locally so that they did not have to be brought from afar, saving on transportation costs.

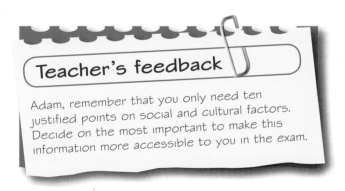

Teacher's feedback

Adam, remember that you only need ten justified points on social and cultural factors. Decide on the most important to make this information more accessible to you in the exam.

Adam's prelim response

This was the question Adam was asked in his prelim exam. He felt that it wasn't ideal for the topic he had studied, as he had more to write about issues that were not asked about. He would rather have been asked about fitness for purpose and style, for example. However, Adam had been taught how to apply exam technique so that he was able to answer the question effectively, no matter what he was asked.

Answer this question with reference to any design work(s) you have studied.

a) Discuss the designer's(s') *use of materials* and/or the *target market* for the design work(s). **10**

b) Explain the influence of *social, cultural* and/or *other factors* on any of the design work(s) discussed. **10**

	Adam's prelim response	Marks
(a)	A design which I have studied is the Red House, designed in 1859 by Philip Webb and William Morris, as the house was designed to be a family home.	
	The house derives its name from the use of local materials such as red brick and red roof tiles, which give it a distinctive appearance and its dominant red colour. Use of these materials mean that although the house integrates with its surroundings to an extent, the dominant red colour means that it can be seen from a distance which gives it visual impact. Use of exposed red brick for the exterior gave the house its name and revealed the innate natural beauty of the construction materials. Morris believed in using materials unadorned which reflected his philosophy on how they should be used and the honesty which he tried to communicate in his designs. In the construction of the Red House, Morris and Webb valued the properties of natural materials, which they thought were far superior to and healthier than industrially produced materials.	✓ ✓ ✓ ✓
	Local and vernacular materials were used when building the Red House, such as red brick, red roof tiles and English oak. This was more environmentally sustainable in an age when that was an unfamiliar concept and when exotic materials were being imported from abroad.	✓
	The use of these materials required skilled craftsmanship and Morris returned to the medieval Gothic methods of craftsmanship. Although he aimed for affordability and anti-elitism, this could not be sustained as hand-crafting techniques were time-consuming and expensive and the materials used to construct the house and its furnishings were not always cheap.	✓
	Glass was a material used to create a variety of different window types, which adds to the individuality of the building's appearance. These include tall casements, hipped dormers, round-topped sash-windows and round windows. Stained glass windows made with traditional materials and techniques were also installed in the house, with medieval-inspired designs created by Burne-Jones and Webb. These flood the interior with coloured light and add to the neo-Gothic ambience.	✓
	The target market for the house was Morris and his wife and it was specially designed and constructed as their family home.	
	Morris also had the idea that it could be used as a meeting place for like-minded artists and designers, and gatherings were often held in the house with several prominent artists, writers and thinkers attending. This group became a secondary target audience and the artist Burne-Jones said it was 'the beautifullest place on Earth'.	✓
	Morris sold the Red House after only living there for five years. Although it was designed specifically for himself and his wife, and it was thought that it would meet the needs of this target market effectively, he found that the house was too expensive to run and it did not suit his lifestyle as much as he thought it would. The house is north-facing, meaning the interior of the house was cold in the winter. Its isolated location became an issue as it was a three-mile journey by carriage from the house to the nearest railway station. It took Morris up to four hours a day to get to his offices, which was impractical.	✓
	The Red House was a private residence until 2003, when it was acquired by the National Trust. It is now a tourist attraction and the target market is now tourists and the house has many visitors each year.	✓
		10

(b)	The Red House is predominantly influenced by the Arts and Crafts Movement and it was constructed using this movement's ethos on craftsmanship and artisan skills. Throughout the house examples of traditional craftsmanship can be seen in the construction and in the interior decor.	✓
	At Oxford, he also developed an interest in medieval history and medieval architecture, inspired by Oxford's many medieval buildings. For example, the passage which connects the main hallway to the house's rear entrance was called The Pilgrim's Rest as a reference to the route taken by medieval pilgrims travelling to Canterbury.	✓
	Morris previously worked for Oxford-based Gothic revival architect George Edmund Street and this influenced the style of his work as he was later to develop the neo-Gothic style in the design of the Red House. He also worked there with Philip Webb, with whom he collaborated on the Red House.	✓
	Vernacular architecture was an influence on the house. Morris and Webb were influenced by vernacular styles of architecture, so the building's appearance reflects the traditional style of cottages that would have been built in that area previously.	✓
	The rejection of Victorian values and the products and processes of the Industrial Revolution was a key influence on the design of the house and its interior. The overly ornamented and mass-produced items seen at the Great Exhibition of 1851 horrified Morris and he became part of Britain's growing Medievalist movement. The style of the Red House and its furnishings was inspired by this return to simplicity and the idea that the ornament should be serving a purpose, or not be included at all.	✓
	Morris was influenced by the effects that the Industrial Revolution was having on the environment, society and workers employed in factories. In the Red House, none of the furniture was made in factories, but was hand-crafted using traditional techniques instead. Morris wanted to create a pre-capitalist sense of community in the house and succeeded in doing so when it became a hub for artists and writers to meet. All who visited admired the style of the house and the honesty with which it had been constructed.	✓
	Furthermore, the writings of art critic John Ruskin, particularly 'On the Nature of Gothic Architecture', were an influence on the Red House. Morris was inspired by Ruskin who believed that the inexpensive, factory-made goods flooding the markets had a negative effect on both those who made them and those who bought them. In commissioning all of the furniture and decoration in the Red House to be hand-crafted, Morris tried to raise artisans to the status of artists. All of the furnishings were made according to the Medieval Guild's model of hand-crafting the items from start to finish as opposed to items being made on a factory production line.	✓ ✓
	Socialism and Social Reform was an influence; the servants' quarters were larger than in most contemporary buildings, reflecting the new ideas on working-class conditions which would lead Morris and Webb to become socialists in later life.	✓
	The Pre-Raphaelite painters Edward Burne-Jones and Dante Gabriel Rossetti were an influence, as both of them aided him in decorating the House. They painted romantic, pre-Raphaelite style murals which remain to this day. In turn, the painters were influenced by Arthurianism and the Age of Chivalry. They produced decorative art based on the legends of King Arthur – murals and decoration in the interior of the Red House reflect this interest. A mural by Burne-Jones depicts the marriage feast of Sir Degrevant – a knight of the Round Table.	✓
	The Victorian 'Cult of Domesticity' was influential on the design of the house. This idea saw the home as a sanctuary from the negative influences of city life. The Red House was such a sanctuary for Morris and the frequent visitors who went there.	✓
		10 **Total: 20**

Teacher's feedback

This is a fantastic prelim performance, Adam. All your preparation has paid off. You have coped well even with this question which wasn't the most suitable for your topic.

You have stayed focused on the question and every statement is well justified and linked to the Red House.

Your answer shows an excellent understanding of your Design studies topic.

Now you have to keep working towards the final exam – don't be complacent!

COMMON MISTAKES

In their exam, students are sometimes thrown if the question is not what they expect. When Adam was asked about target market, it was not what he was expecting or hoping for. Instead of panicking, he answered on the other issue, materials, which he knew a lot about. Then he thought about how he could connect what he knew about the Red House to target market and found that there was quite a lot to say.

He was only able to do this because he knew his topic inside out and had a good understanding of how design issues relate to each other.

HINTS & TIPS

Adam realised that part (b) in Questions 7 and 8 is likely to be very similar from one year to the next. He ensured that he was well prepared and that he could write at least 10 marks' worth on social, cultural and other influences on his selected design. You should do the same!

HINTS & TIPS

In Questions 7 and 8 part (a) you will always be given **two** prompts. However, the question gives you the option of responding to both prompts or just one. Therefore, it is still possible to gain full marks by writing about only one prompt, as long as you write enough to demonstrate a sound knowledge and understanding of the selected prompt in relation to your chosen design work(s).

Chapter 5

External Assessment:
Portfolio Gallery

5

External Assessment: Portfolio Gallery

Your Higher Expressive and Design Portfolios are submitted to SQA to be marked. Your work is suspended from racks while it is being marked. A variety of formats can be used and you should consider which will work best for your Portfolio.

You are allowed to submit up to 3 × A2 sheets, or the equivalent. You can submit less and there is no requirement to send in the maximum amount. Sometimes 'less is more'. A well-edited selection may communicate your ideas better than a Portfolio which is padded out with irrelevant work, and which might even be confusing.

On the following pages you will see examples of actual exam Portfolios and their varying layout formats.

Candidate A

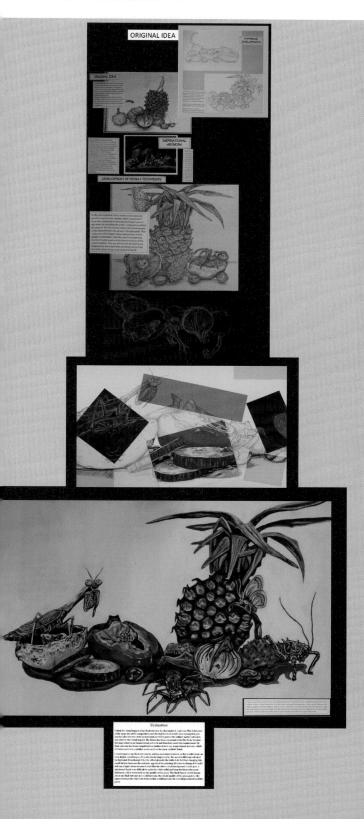

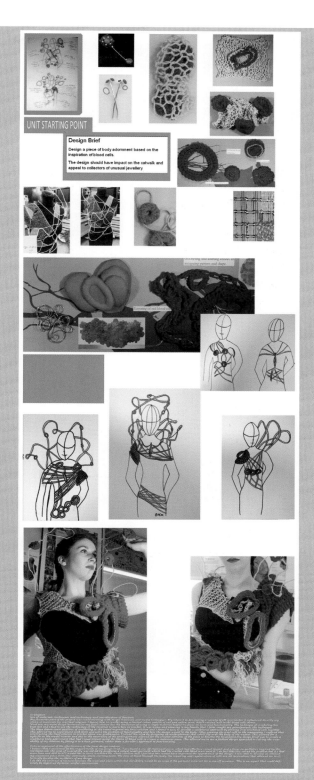

3 x A3
1 x A2
Evaluation of Portfolio included throughout development.

Evaluation of final piece on the last sheet

2 x A2

Evaluation of Portfolio included throughout development.

Evaluation of Design solution on the last sheet

Candidate B

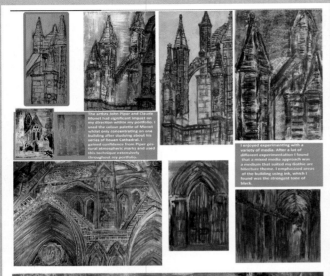

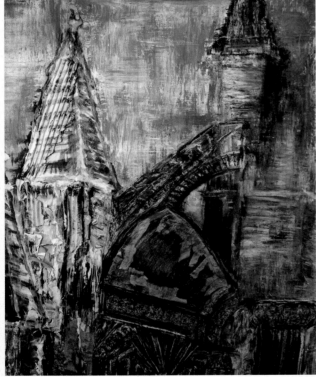

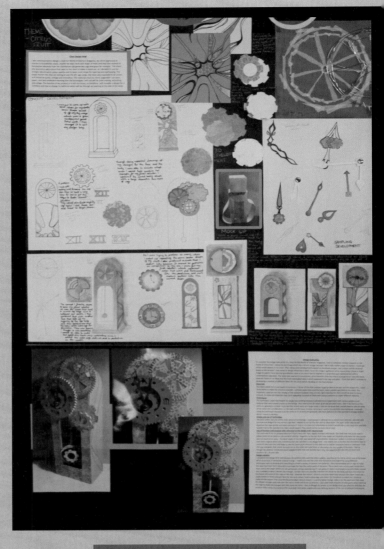

1 x A1

Some evaluation of Portfolio included throughout development.

Evaluation of Portfolio and Design solution on the last sheet

1 x A2
1 x A1
Some evaluation of Portfolio included throughout development.

Evaluation of Portfolio and final piece on the last sheet

HINTS & TIPS

As the Portfolios are hung up using bulldog clips, vertical formats tend to be more effective. Horizontal formats are acceptable, but vertical formats usually hang better and are easier for examiners to view.

Candidate C

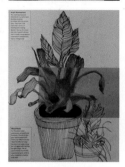

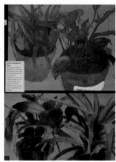

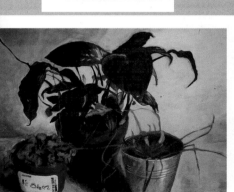

4 x A4
1 x A2
Some evaluation of Portfolio included throughout development.

Evaluation of final piece attached to the last sheet

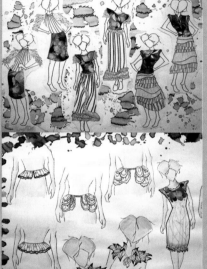

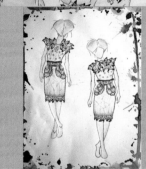

2 x A4
4 x A3
Evaluation of Portfolio and Design solution attached to the last sheet

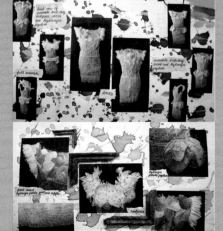

Candidate D

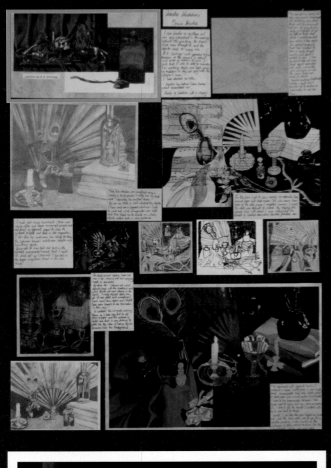

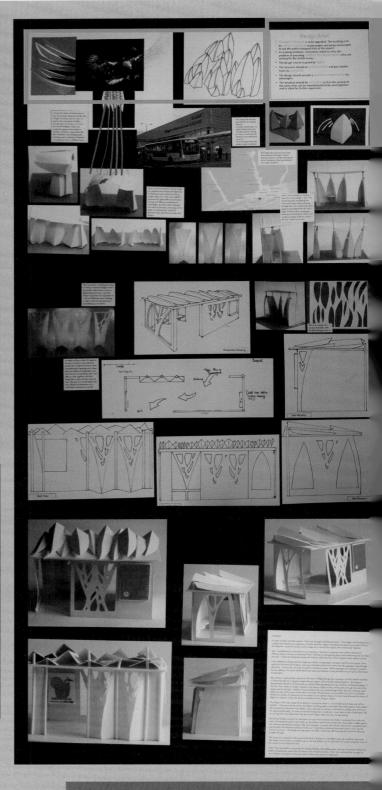

1 x A1

1 x A2

Some evaluation of Portfolio included throughout development

Evaluation of Portfolio and final piece on the last sheet

3 x A2

Some evaluation of Portfolio included throughou development

Evaluation of Portfolio and Design solution on th last sheet

Chapter 6

Wordbanks

6 Wordbanks

To complete your investigation of art and design works successfully and do well in the Question Paper, it is important to extend your range of vocabulary and build up a good understanding of Art & Design terminology.

We will start with the **visual elements**, which artists and designers use in different combinations for visual effect.

The visual elements

Line

Line can be used to show shape and form when drawing or painting.

Texture and pattern can be represented through line.

Line can express mood and emotion in Expressive Art.

In Design, line can be used to communicate ideas and can affect the style of a design.

Words about line					
thick	angular	outline	flowing	zigzag	continuous
thin	rectilinear	horizontal	graceful	jagged	broken
broad	rough	vertical	elegant	twisting	ragged
straight	textural	diagonal	precise	cross-hatched	scratchy
curved	expressive	wavy	accurate	stripe	inconsistent
long	bold	curvilinear	sensitive	neat	freehand
short	confident	fluid	delicate	sketchy	gestural
hard	hesitant	smooth	controlled	faint	spontaneous
light	fine	squiggly	definite	subtle	

Tone

Tone can be used to show the variation from light to dark.

Tone can be used in drawing to describe 3D form, pattern and texture.

The direction and source of light in a drawing or painting can be shown through tone.

Tone can be used expressively or to create a sense of realism or to show mood and atmosphere.

Words about tone

light	highlight	limited tonal range	dramatic	hard light	drab
dark	half-tone	wide tonal range	contrasting	diffused light	faded
soft	mid-tone	tonal value	exaggerated	high key	sombre
subtle	monotone	tonal scale	hard	low key	gloomy
muted	graduated	light source	glowing	reflected light	murky
gradation	graded	direction of light	luminous	reflection	dim
blended	shaded	shadow	illuminated	bright	flat

Colour

Colour can convey mood in Expressive Art.

We often associate colour with emotion.

Colour can be used to enhance a design or to attract a certain target market.

In Design, colour can contribute to style.

The colour wheel

Words about colour

primary	transparent	bright	monochromatic
secondary	opaque	strong	neutral
tertiary	hue	harsh	subtle
complementary	pigment	vibrant	restrained
opposite	tone	intense	limited palette
contrasting	tint	saturated	restricted palette
harmonious	balanced	bold	pale
related	varied	deep	muted
hot/warm	deep	vivid	faded
cold/cool	fluorescent	rich	realistic
symbolic	luminescent	expressive	naturalistic
decorative	pearlescent	exaggerated	life-like
advancing	iridescent	clashing	earthy
receding	lurid	gaudy	delicate
balanced	loud	garish	weak
blended	brilliant	polychromatic	washed out
reflected colour	kaleidoscopic	multi-coloured	pure

Primary colours

Red, yellow and blue are primary colours and cannot be mixed using other colours.

Harmonious colours

These are the groups of colours that are next to each other on the colour wheel – for example, green, turquoise and blue, or red, orange and yellow. They are sometimes called analogous colours.

Complementary colours

Complementary colours are opposite each other on the colour wheel. For this reason, they are sometimes called opposite colours. When used together, they tend to clash.

Secondary colours

Secondary colours are made by mixing two primary colours. These are purple (blue and red), orange (red and yellow) and green (blue and yellow).

Tertiary colours

Tertiary colours are made by mixing the three primary colours together. Depending on the amount of each colour, different results will be achieved. Tertiary colours are a variety of browns or greys.

Tints, tones and shades

Tints are made by adding a colour to white.

Tones are made by adding grey to a colour.

Shades are made by adding black to a colour.

Texture

Texture can be used to describe how a surface feels or looks.

Texture can be represented using 2D techniques.

3D techniques can be used to create surface texture.

Words about texture			
tactile	furry	even	brushstroke
touch	scaly	uneven	impasto
textural	silky	grainy	bas relief
soft	hairy	indented	low relief
hard	rippled	pitted	linear
rough	wrinkled	dusty	swirling
smooth	crinkled	waxy	dashed
coarse	ribbed	greasy	directional
fine	grooved	velvety	random
flat	spiky	fleecy	bumpy
shiny	scratched	woolly	woven
glossy	abrasive	matt	

Shape

Shape defines a two-dimensional area.

Shape can help to communicate design ideas and can contribute to the style of a design.

Shapes can be repeated to make patterns.

Form

Form is three-dimensional shape.

Form can be used in sculpture, low relief work or in 3D design.

In Expressive Art, form can be used to show realism.

In Design, form can contribute to style.

sphere **cube** **cylinder** **cone** **pyramid**

Words about shape and form

Shape and form		Shape		Form	
regular	simple	circular	sphere	sculptural	
irregular	complex	rectangular	cube	architectural	
geometric	fragmented	oblong	cylinder	profile	
organic	jagged	square	pyramid	relief	
man-made	pointed	triangular	cone	moulded	
natural	distorted	oval	conical	sculpted	
angular	freeform	pentagon	helix	modelled	
rounded	bold	hexagon	spherical	carved	
symmetrical	distinct	octagon	cuboid	built	
asymmetrical	indistinct	outlined	triangular	constructed	
flat	spiral	positive	tactile	assembled	
repeating	twisted	negative	textural	tool marks	
elongated	large-scale	overlapping	massive	solid	
simplified	small-scale	silhouette	monumental	hard	
stylised	short	negative space	hollow		
spiky	tall	amorphous	light		
hard-edged	wide	nebulous	heavy		
soft	narrow	fluid	mass		

Pattern

Pattern is an arrangement of repeating elements or motifs: lines; shapes; forms; tones; or colours.

Pattern can be used to enhance Expressive Art work or Design ideas.

Pattern can be found in the natural and man-made environments.

Words about pattern

applied	random	dots	decorative
repeating	varied	polka dot	ornate
simple	regular	dashes	ornamental
complex	linear	lines	embellished
man-made	rectilinear	stripes	bold
natural	curvilinear	chequered	subtle
geometric	rhythmic	tartan	clashing
organic	symmetrical	plaid	kinetic
mechanical	asymmetrical	floral	optical
motifs	symbols	speckled	digital
squiggles	mirror image	marbled	abstract
large-scale	multi-directional	cross-hatched	psychedelic
small-scale	half-drop	stippled	tessellated

Expressive art

Composition

Composition is the arrangement of elements within a painting, drawing or photograph.

In sculpture, composition is about the spatial arrangement of 3D forms.

Artists use composition to lead the viewer's eye around the work in a particular way.

Words about composition				
arrangement	viewpoint	focal point	subject	sitter (in portraiture)
foreground	framed	centre of interest	object	subject matter
middleground	cropped	point(s) of interest	distorted	frame within frame
background	close-up	elevated viewpoint	fragmented	in proportion
horizontal	wide angle	camera angle	symmetrical	out of proportion
vertical	circular	eye-level	asymmetrical	portrait orientation
diagonal	triangular	bird's eye view	balanced	landscape orientation
linear	staged	low viewpoint	busy	one-point perspective
horizon line	set up	picture plane	cluttered	two-point perspective
perspective	dynamic	negative space	crowded	flattened perspective
leading line	small-scale	rule of thirds	minimalist	aerial perspective
s-curve	large-scale	depth of field	sparse	vanishing point

Mood and atmosphere

By using different combinations of the visual elements and a variety of techniques, artists can create a variety of different moods in their work.

Words about mood and atmosphere				
tranquil	exciting	atmospheric	violent	sad
peaceful	busy	overcast	disordered	pessimistic
quiet	fun	gloomy	aggressive	melancholy
serene	happy	sunlit	hostile	depressing
calm	joyful	sun-drenched	moody	dismal
informal	passionate	shadowy	intense	desolate
relaxed	flamboyant	warm	threatening	lonely
still	lively	cold	disturbing	sensitive
undisturbed	optimistic	leaden	powerful	thought provoking
controlled	emotional	dreary	inspiring	moving
dispassionate	expressive	lack-lustre	poignant	breathtaking

Design

Aesthetics and style

Aesthetics is about appearance.

Each designer has their own distinctive style which affects the appearance of their designs.

Different aesthetics appeal to different target audiences.

The visual elements will affect the style of a design, so you should refer to these wordbanks as well.

Words about aesthetics and style			
line	antique	gothic	appealing
colour	traditional	rococo	attractive
shape	classical	baroque	visual impact
form	Victoriana	romantic	decorative
pattern	minimalist	Arts and Crafts	ornamental
texture	vintage	Art Nouveau	sophisticated
source of inspiration	retro	Art Deco	elegant
influences	futuristic	modernist	sculptural
the 'look'	industrial	punk	tasteful
appearance	original	contemporary	flashy
layout	quirky	up-to-date	experimental
arrangement	idiosyncratic	sleek	eclectic
text	kitsch	streamlined	eccentric
font	avant-garde	fun	statement piece
use of space	ahead of its time	funky	conversation piece

Function

Function is about the purpose of a design.

Designers have to consider functional issues, even in very decorative pieces.

Words about function			
purpose	ergonomics	durability	eco-friendly
intention	user-friendly	fragile	sustainability
rationale	technological	delicate	safety
protoype	mechanical	built in obsolescence	risk
concept	high-tech	disposable	danger
fitness for purpose	digital	hard-wearing	hazard
functionality	computerised	robust	secure
wearability (fashion)	microtechnology	sturdy	protection
suitability	nanotechnology	built to last	weight
practicality	robotic	multi-functional	scale

Target market

Designers have to consider their target market, whether this is one client, a specific group or the mass market.

Words about target market			
design brief	gender	age group	cost
client	male	age bracket	budget
specification	female	babies	added value
commission	unisex	children	income bracket
one-off	designer label	teenagers	disposable income
limited edition	diffusion line	young adults	customer type
mass produced	high street	adults	socioeconomic group
mass-market	middle-market	couples	cost effective
disposable	commercial	families	status symbol
sustainable	trendy	general public	value for money
eco-friendly	fashionable	demographic	promotion
market research	exclusive	niche market	persuasion
market forces	target audience	up-market	consumer appeal

Chapter 7
Useful Resources

Useful Resources

Learning resources and inspiration	www.studentartguide.com
Image website for research	www.pinterest.com
National Galleries of Scotland	www.nationalgalleries.org
National Gallery, London	www.nationalgallery.org.uk
National Portrait Gallery	www.npg.org.uk
Tate Galleries	www.tate.org.uk
British Museum	www.britishmuseum.org
Crafts Council	www.craftscouncil.org.uk
Design Museum	www.designmuseum.org
Victoria & Albert Museum	www.vam.ac.uk
Design Council	www.designcouncil.org.uk
Pompidou Centre, Paris	www.centrepompidou.fr
Guggenheim Museum	www.guggenheim.org
Museum of Modern Art, New York	www.moma.org
Courtauld Gallery	www.courtauld.ac.uk/gallery
Institute of Contemporary Art	www.ica.org.uk
Conceptual art	www.saatchigallery.com
Contemporary art online gallery	www.saatchiart.com
Contemporary art gallery	www.whitecube.com
Flowers Gallery	www.flowersgallery.com
Imperial War Museum	www.iwm.org.uk
Print-making	www.glasgowprintstudio.co.uk
British Journal of Photography	www.bjp-online.com
National Media Museum	www.nmpft.org.uk
Magnum Photos	www.magnumphotos.com
Artist Encyclopaedia	www.artcyclopaedia.com
Web Museum online art gallery	www.ibiblio.org
Museum and gallery websites	www.gallerywebsites.co.uk
Online architecture & design magazine	www.dezeen.com
Online design magazine	www.designboom.com
Historical fashion & costume	www.costumegallery.com
Promoting felt-making worldwide	www.feltmakers.com
Textile artists' group	www.62group.org.uk
Public sculpture	www.pmsa.org.uk
Dazzle Jewellery	www.dazzle-exhibitions.com/designers
Contemporary jewellery & sculpture	www.velvetdavinci.com
Contemporary jewellery	www.klimt02.net
Fashion magazine	www.vogue.com
Royal Institute of British Architects	www.architecture.com
Architectural Association	www.aaschool.ac.uk